sourcebook for working with battered women

A comprehensive manual specifically designed for counselors, ministers, social workers, educators, and support group leaders who want to improve the content, relevancy, and participation of discussion for abused women in group or individual settings.

by Nancy Kilgore

VOLCANO
· PRESS ·

Volcano, California

Copyright © 1992 by Nancy Kilgore. First published by Learning Information For Today, 1992.

First Volcano Press, Inc. edition, 1993.

Printed in the United States of America.

Library of Congress Cataloging-in-Publication Data

Kilgore, Nancy, 1949–

 The sourcebook for working with battered women : a comprehensive manual specifically designed for counselors, ministers, social workers, educators, and support group leaders who want to improve the content, relevancy, and participation of discussion for abused women in group or individual settings / by Nancy Kilgore.

 p. cm.

 Includes bibliographical references.

 ISBN 0-912078-97-9 : $17.95

 1. Abused women—Counseling of—United States. 2. Social work with women—United States. 3. Social group work—United States. I. Title.

HV1445.K55 1993

362.82'9205323—dc20 93-18367

 CIP

Volcano Press participates in the Cataloging in Publication program of the Library of Congress. However, in our opinion, the data provided above by CIP for this book does not adequately nor accurately reflect the book's scope and content. Therefore, we are offering our librarian and bookstore users the choice between CIP's treatment and an Alternative CIP prepared by Sanford Berman, Head Cataloger at Hennepin County Library, Edina, Minnesota.

Alternative Cataloging-in-Publication Data

Kilgore, Nancy, 1949–

 The sourcebook for working with battered women: a comprehensive manual specifically designed for counselors, ministers, social workers, educators, and support group leaders who want to improve the content, relevancy, and participation of discussion for abused women in group or individual settings. Volcano, CA: Volcano Press, copyright 1993.

 PARTIAL CONTENTS: Battered women in support groups. Lesson plans. –Readings. –Visualizations. –National resources. –National helplines.

 1. Battered women—Psychology. 2. Battered women—Self-help materials. 3. Battered women's services—Directories. 4. Battered women's self-help groups. 5. Self-esteem in battered women. 6. Battered women—Group psychotherapy. 7. Social group with battered women. I. Title. II. Title: Battered women sourcebook. III. Title: Working with battered women sourcebook. IV. Volcano Press. 362.882

Design/Production: David Charlsen

Typesetting: ImageComp

Editorial: Zoe Brown and Ann Sharkey

Please enclose $17.95 for each copy of *Sourcebook for Working with Battered Women* ordered. For postage and handling, please include $4.50 for the first book and $1.00 for each additional book. California residents add appropriate sales tax. Please contact Volcano Press for quantity discount prices.

Volcano Press, P.O. Box 270 SB, Volcano CA 95689. Telephone: (209) 296-3445 Fax: (209) 296-4515.

Please see order form on page 119 for additional titles from Volcano Press, or write for a current catalog.

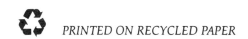

PRINTED ON RECYCLED PAPER

CONTENTS

ACKNOWLEDGMENTS

This book is dedicated to my son. You are the light that has shown me unconditional love.

Mom, thank you for my childhood. You were wonderful.

I wish to thank those women in the shelter who helped me understand what "domestic violence" meant. I want to thank that woman who held me when I cried.

I want to thank Alan Newcomer for being a "sounding board." Thank you for letting me use the computer and innumerable resources.

I am eternally grateful for the generosity and inspiration of Lisa Tureco, Jackie Newcomer, Bob Saunders, and Pat Ackerman.

And, I am grateful to Burton Johnson for the learning and the energy that is with me as I go towards God's plans. You are a "Chaplin." I see your gifts.

INTRODUCTION

Throughout America, war is now taking place inside so many homes. We read the horror stories in the news every week. Boy shot while trying to defend his mother against his father. Police find woman savagely stabbed by boyfriend. Mother admitted to emergency room with multiple fractures. We read a little and turn the page. It's too much.

An act of domestic violence occurs every eighteen seconds.

I'm tired of all the statistics that point to the rising increase of domestic violence. Tired of reading them, tired of listening to experts quote them. I'm tired of the fact that so many children in this cycle will suffer irrevocable emotional damage. Our families need healing. It's time for action.

On July 21, 1979, I was brutally beaten by the man I loved. I became a victim of what the U.S. Surgeon General states as the single largest cause of injury to women in the United States. I carry the physical and emotional scars of a battered woman. I can still hear the sounds of war in my brain, and the grisly slides are still projected in my mind.

The foundation for *Sourcebook for Working with Battered Women* is a book I wrote twelve years ago about my personal involvement in domestic violence: *Every Eighteen Seconds*. It is a distillation of the feelings of anguish, despair, anger, and humiliation I once suffered. This book, written as a series of letters to my son, has proved itself cathartic in helping battered women discuss background histories of abuse. *Every Eighteen Seconds* is written with a warmth and identification that offers hope to women enmeshed in the intricate mosaic of domestic violence. To the clients that you will touch it offers a testament to help them gather strength to survive, live, and flourish in the next chapters of their lives. I strongly recommend that you read and share it. (See order form in back of book).

This year thousands of women will enter love relationships with great hopes for success. Sadly, many of these women will also become victims of domestic violence. A storm rips through the doors of so many homes in America. It is time to get prepared. Our minds must invent solutions and put energy behind good ideas. We must make a personal commitment. We must focus on a positive vision for families touched by domestic violence. At least one woman was beaten while you read this.

It takes a great deal of knowledge to work with a woman who has been the victim of abuse. I know that fact personally. I am a support group leader and workshop facilitator who has taught many battered women. I have taught therapists, social workers, and ministers about how to work with battered women. I am an educator. I believe that battered women can learn that they are worthy of having a life of joy and happiness.

Battered women need skilled assistance to rebuild feelings of control and self esteem. They need to overcome fears, clarify feelings, understand options, and make rational decisions. As a counselor, social worker, minister, or support group leader, you can do so much to move domestic violence out of the dark, unspeakable shadows. Know that you have a critical role to play as our society breaks down the wall of silence and privacy surrounding violence within families.

The most helpful counseling session or support group for these women is one that is organized around a discussion format. This guide is designed to help you create that discussion and take abused women out of isolation. It can be used with an individual client or group. It

provides a format that allows a woman to openly discuss her painful experiences. This format will also give her new information and participation in ideas that she will need to rebuild feelings of control and self esteem.

Sourcebook for Working with Battered Women has four basic sections: 1. Working with battered women; 2. Battered women in support groups (this section includes lesson plans and can also be used in individual therapy); 3. Material components: self-help readings, handouts, and resource listings; and 4. Helpline telephone numbers.

WORKING WITH THE ABUSED WOMAN

Why Do Women Stay?

Women are taught that their main societal role and means of financial support is as the mother, wife, and homemaker. Many women believe that they can find fulfillment and satisfaction as the unpaid home providers of all comforts, love, and nurturing. If a woman finds herself living in a violent home, she often feels ashamed, guilty, and inadequate. The abused woman feels that she has failed to meet society's expectations. She is subjected to many messages that contribute to feelings of guilt:

- Marriage is forever.

- Women need to keep the family together.

- Women should obey their husbands.

- Drinking causes men to batter.

Economic dependence often keeps battered women tied to their men despite the abuse. Many abused women have no access to funds or transportation, nor do they have a safe place to go to. A battered woman does not often get support to leave. She hears many messages that produce guilt from those closest to her:

- "You married the guy; now lie in your bed."

- "If you weren't such a flirt he might have more respect for you."

- "Why don't you try to work things out? He's such a good provider."

- "How do you expect to support these kids?"

Her internal messages to herself are often quite unsupportive as well:

- He wouldn't be able to live without me.

- The children need a father.

- I have no education and no skills.

- I'll lose my kids.

- I can't give up my dream of a good marriage.

- I can't make it on my own.

- I'm afraid of being lonely.

Many women do not want a divorce. Divorce may be against a woman's religion. Separation may involve more responsibilities than she knows how to handle. These women often do not have the self-assurance or survival skills needed to establish independent lives. Because she

developed a dependence to her husband she feels as incapable of living alone as a twelve-year-old. In the first year after a divorce, a woman's standard of living drops by 73 percent, while a man's improves by an average of 42 percent.

Isolation and feelings of powerlessness are common among abused women. The abused woman may come to believe that she provoked the violence. Her mind is not logical because she is being psychologically battered. She'll continually second-guess herself:

- Was I wrong?

- Was I right?

- Was I as bad as he said?

- Could I do it better next time?

- What else could I have done?

- How can I make him feel better?

- What should I do the next time?

Effects of Abuse

The effects of abuse are serious and long lasting. Abused women suffer memory blackouts and long-term depression and are often suicidal. Like Vietnam War veterans, many of these women have symptoms of post-traumatic stress disorder. Their symptoms include:

- Mental flashbacks

- Intense lifelike memories or recurrent bad dreams of events related to the abuse

- Sudden rush of feelings that abuse is presently taking place

- Sleep disturbances

- Difficulty in concentrating

- Avoidance of activities that arouse remembrance of the abuse

The abused woman's fear of being found and subjected to worse abuse is very real. Research over the last ten years indicates that women who leave their batterers are at a 75 percent greater risk of being killed by the batterer than those who stay (Barbara Hart, Esquire, October 1988).

What Is Abuse?

It is important that you have a definition of abuse: Abuse is a pattern of control that physically harms, induces fear, prevents another from doing what they wish, or forces them to perform in ways they do not want to. Abuse can be found among married and unmarried heterosexuals, lesbians and gay males. It cuts across geographic, religious, economic, and racial barriers. Abuse includes physical, sexual or emotional attacks.

Physical abuse is: pushing, scratching, slapping, hitting, punching, choking, kicking, holding, biting, or throwing; locking you out of the house, driving recklessly when you are in

the car, throwing objects at you, threatening to hurt you with a weapon, abandoning you in dangerous places, refusing to help when you are pregnant, injured, or sick.

Sexual abuse is: insisting that you dress in an uncomfortable sexual way, calling you sexual names like "whore," or "bitch," forcing you to strip, forcing unwanted sexual acts, withholding sex, criticizing you sexually, insisting on unwanted touching, assuming you would have sex with any available man.

Emotional abuse is: ignoring your feelings, ridiculing your beliefs, withholding approval, threatening to take your children, telling you about his affairs, manipulating you with lies, threatening to leave you, taking the car keys or money, keeping you from going to work or school, humiliating you in public or private, abusing your pets or children, calling you names or driving your family or friends away.

In order for you to understand why the abused woman stays, you must become acquainted with the characteristics of an abused woman and those of the abusive male.

Characteristics of Many Abused Women

For clarity in these descriptions, "husband" is analogous to "cohabitant," "partner;" "marriage" to "relationship."

1. Abused women are found in all socioeconomic and educational levels, and in all racial groups.

2. The abused woman has a martyr-like behavior. She is often a long sufferer and overloaded with the demands of others. The abused woman has difficulty nurturing herself and feels unappreciated.

3. She is often not allowed control of any finances.

4. Problem solving is very stressful. The abused woman doesn't know how to deal with stress and can often have anxiety attacks. Usually this type of woman will feel tired and overworked. She doesn't provide enough space in her life for breaks.

5. She accepts "responsibility" for the batterer's violent behavior.

6. The battered woman is isolated and is losing contact with her family or friends. She often feels embarrassed about her situation. This type of woman is further isolated because her partner doesn't want her to give time to friends, neighbors, relatives, or outside activities. He wants all the attention himself.

7. She suffers from guilt. This woman may feel that she deserves to be beaten because she is not able to live up to her husband's expectations.

8. The abused woman is a traditionalist about her role in the home. She strongly believes in family unity and has traditional expectations of husband or cohabitant as the provider. This type of woman often doesn't like her role and can "nag." She wants to keep the image of a socially or religiously acceptable marriage.

3

9. The abused woman has low self-esteem and does not feel valued. She is extremely critical of herself. She does not possess a high level of self-preservation.

10. She accepts violence in hope that some day she will be able to change her mate. She believes that she caused the anger and violence. She usually loves her husband and wants to trust his promises that he'll reform, although this rarely happens.

11. Many battered women were emotionally neglected as children. Possibly, she was physically and/or sexually abused as a child or saw violence in her family. She could have been abused by a sibling, parent, or other relative.

12. It's difficult for the battered woman to verbalize her needs and desires to others. She has poor communication skills and has difficulty in being able to express her anger. Because she is unassertive, she can be quite manipulative. She is skilled in the art of complaining. Her complaints usually are not listened to or resolved by her partner.

13. This woman's mind is often in denial. She may not admit to herself that she has been physically, emotionally, or sexually abused. She often gives herself excuses for her husband's violence. The abused woman may think of each incident as an "accident." The abused woman is a great rationalizer: "He's a great provider."

14. From her childhood she was taught to defer power to a male. She feels helpless and will look for someone to help her put her life together. She does not want to take responsibility for making decisions and would rather have someone else make them. Many abused women feel comfortable taking a "compliant" position. She has been brought up to believe that women are weak and inferior and should submit to men in return for financial support.

15. This woman may have sexual problems because of unresolved anger toward her abusive husband.

16. The abused woman is often depressed. She may try to make herself less depressed with alcohol, drugs, shopping sprees, over-cleaning, overeating, etc. She may contemplate suicide.

17. She is at high risk of being hit on the face or head area. During pregnancy she is often hit in the abdomen.

18. The abused woman often receives jealous accusations that she cheats on her partner. Her elaborate attempts to convince him otherwise are unsuccessful.

19. Because of the abuse she suffers, she can hit her own child(ren) and then feel extremely guilty.

20. The abused woman is usually willing to "mother" an emotionally immature man. These women feel that they are expected to act more like mothers than wives.

Characteristics of Many Male Batterers

For clarity in these descriptions, "wife" is analogous to "cohabitant," "partner;" "marriage" to "relationship."

1. He is found in all socioeconomic levels, all age groups, and all racial groups. Many batterers have police records.

2. He has a low self-esteem. Many are insecure about their worth as providers, husbands, or sexual partners.

3. He blames others for his actions. He has poor impulse control and can have explosive temper outbursts. He has a low toleration for frustration.

4. He doesn't believe his violent behavior should have negative interpretations. He has no awareness of, or guilt for, violating his wife's boundaries.

5. He probably has a family history of domestic violence. He may have witnessed the physical or emotional abuse of a close relative. The batterer has not acquired the necessary social lesson that beating up a woman is wrong.

6. He can employ some of the following weapons: fists, feet, gun, knife, broom, belt, brush, pillow (to smother), hot iron, or lighted cigarette.

7. His expectations of relationship are unrealistic. He expects his wife to conform to his fantasies, and his expectations are often unspoken. He has insatiable childlike needs and believes that his partner or children "ought to" conform to his beliefs.

8. He is emotionally dependent on his wife and children. He makes sure that his partner will not escape by keeping car keys and money, ripping the phone out of the wall, etc. When his partner threatens separation, he may exert control by threatening homicide and/or suicide.

9. He may experience a high level of job dissatisfaction, underemployment, or unemployment which leads to feelings of inadequacy.

10. He has poor communication skills. The abuser sees violence as a viable method of problem solving and as an acceptable means of controlling a family.

11. He can have an unpredictable and confusing personality.

12. He is a traditionalist, believing in male supremacy. In family matters, batterers think that they must be in charge; women should be submissive and content to be controlled. Abusive males do not believe their forcible behavior is a crime; it is aimed at keeping the family intact. He frequently keeps his partner isolated from society—as well as from friends, neighbors, and even family.

13. He tends to be jealous and make accusations of cheating. He can voice great fear that his partner will abandon him. The batterer can employ clever espionage tactics against his mate: checking the gas mileage when his partner does errands, eavesdropping on his partner's telephone conversations, etc.

14. He can plead that his violent behavior has great potential for reform. He can make many promises and then forget that he made them.

15. He can inflict invisible injuries. Many abusers cause injury to the abdomen during pregnancy.

16. Those closest to him know that he is characterized by depression and self-pity. The batterer often feels that no one cared about him in his childhood. He believes that his marriage does not provide the care he needs.

17. His use of alcohol or drugs is often associated with the abuse of his partner and is used as an excuse for abuse, rather than a cause.

The Christian Abused Woman

The Christian abused woman presents a need for a particular understanding and should be spoken with skillfully. She has several powerful messages that contribute to her guilt and not leaving:

- It is your Christian duty to forgive.

- The Bible instructs us to love each other. The family is very important to God.

- Sacrifice for your family. A wife is secondary to her husband.

- The Christian woman must keep her family together.

- Pray for a violent man. God can change him.

- Put your marriage in God's hands.

Be aware of scripture that she will use to rationalize inexcusable abuse:

> Love your enemies, do good to those who hate you, bless those who curse you, pray for those who abuse you. To him who strikes you on the cheek, offer the other also. (Luke 6:27-29.)

> Let love be genuine; hate what is evil, hold fast to what is good. . . Bless those who persecute you; bless and do not curse them. . . Repay no one evil for evil. . . Beloved, never avenge yourselves, but leave it to the wrath of God; for it is written, "Vengeance is mine, I will repay, says the Lord." (Romans 12:9, 14, 17, 19.)

> Do what is right; then if men speak against you, calling you evil names, they will become ashamed of themselves for falsely accusing you when you have only done what is good. Remember, if God wants you to suffer, it is better to suffer for doing good than for doing wrong! Christ also suffered. (1 Peter 3:16-18.)

> Love is very patient and kind, never jealous or envious, never boastful or proud, never haughty or selfish or rude. Love does not demand its own way. It is not irritable or touchy. It does not hold grudges and will hardly even notice when others do it wrong. (1 Corinthians 13.)

It is extremely important to be acquainted with scripture. She can quote scripture. You must be able to quote scripture as well and have comeback statements:

> The Bible is trying to teach us that we should not act out of vengeance. We should not seek to hurt the one who hurt us. To turn the other cheek means that we do not return abuse for abuse. We can walk away from abuse. The Bible does not endorse us to take abuse. There isn't anything loving when a man continues to destroy his family with violence. Violence is evil.

> You can pray for the man who abuses you. You can hope that he recognizes the harm that he is doing. You do not need to stay there and be abused while you wait for him to make the decision to change his abusive patterns. You can get safe shelter for yourself and your children. You can pray for him while you're there.

> You should not have to live in terror. Your home is your sanctuary. You have the right to feel safe. You are a child of God. If your house was on fire, you would call the fire department, wouldn't you? The fire department would help save your house. There are shelters that will provide help for an abused woman who is suffering from abuse. Your home is in crisis. Think of it this way: your home is on fire. You need to call for help.

And last but not least, be prepared for this scripture:

> Honor Christ by submitting to each other. You wives must submit to your husbands' leadership in the same way you submit to the Lord . . .

You could reply:

> This passage does not say that a woman is supposed to put up with abuse. It doesn't mean that a man is to lead a woman. This scripture is the most misread part of the Bible. Read the next statement in the passage: *And you husbands, show the same kind of love to your wives as Christ showed to the church when he died for her . . .* This passage means that both men and women should show the utmost love and respect towards each other.

Communicating with the Abused Woman

The abused woman has probably taken the biggest step of her life to come to your support group or counseling session. She has come out of isolation. Empathize with the abused woman and validate her feelings and experiences. Many abused women feel crazy and self-doubting. You need to take a stand against the abuse and make an alliance with this woman so she can talk about her confusion, guilt, anger, fear, or humiliation. Help the abused woman come out of isolation by "universalizing" abuse. You could use the following to articulate a clear stance about the abuse.

> You are not responsible for his violence, no matter what you do or don't do.

> Keeping the family together is not always the best choice; abuse is wrong, sometimes an abuser has to be left.

> Many women are beaten. Many never know that this happens to others.

Be armed with statistics that you can quickly access from your memory. Give the abused woman the handout entitled "National Statistics on Domestic Violence" (H 3, page 89).

This woman has not been a passive recipient of abuse. She has constantly tried to stop the abuse and protect herself and her children. Her thoughtfulness is often invisible to the outsider. If the situation is in a support group setting she will vigilantly analyze you and the other women to test for emotional safety. The abused woman will ask herself repeatedly if she has placed herself in an unsafe situation. She has many hidden secrets.

The abused woman has great difficulty in being able to open up in a spontaneous manner. She may feel that talking will make her re-experience the abuse. Her batterer might have demanded silence about the abuse or intimated that she was mentally unstable, or threatened her very life. A battered woman may feel that she is risking her life to talk about her involvement in abuse. She has been isolated and controlled for so long that she has probably lost the ability to complete day-to-day maintenance tasks, such as taking care of her child or children, buying groceries, paying bills, or eating. Do not measure your success by the abused woman leaving her partner. Consider it a victory that she can talk to you about the violence.

Life for the battered woman is overwhelming. She is often suicidal, has memory blackouts and long-term depression. Don't use forceful mandates, for example, "You must get a restraining order." You are there to "help" the abused woman plan her life. Your job is to build on the abused woman's experiences, ideas, support networks, community resources. Acknowledge the woman's strengths, the skillful ways she has protected herself or her children, choices she has made to leave the abuse or keep her sanity, and the inner strength she demonstrates by telling you about the violence.

Respect her pace in the process of her own recovery. Battered women cannot change their lives overnight. She might not be emotionally strong enough to leave. Accept that each abused woman must find solutions that she can live with. Allow the abused woman to make her own decisions for her own life. You cannot make her decisions for her. She would only become dependent on you. Do not try to play the role of God.

Battered women leave and return to their abusive partners many times. Do not intimate that this is failure. These women must make several difficult decisions. They have to consider housing or find a job. They may return out of fear, poverty, love, religious beliefs, or concern for their children. They may get pressure from ministers, family, or friends.

Active Listening

If you are a counselor, minister, or social worker, you are already acquainted with active listening skills. Remember to use these skills. Active listening will help your client face her abuse. It will help you to not force your opinion or appear as a "God" to a woman who appears to be very helpless. Try not to give mandates about what she should and shouldn't do. The abused woman knows that when her defenses are down, her internal pain could spill out. This woman needs to experience a supportive environment of understanding. If information about herself that she offers is responded to without acceptance, she may react as though it were another abusive attack.

If you are not trained in active listening skills (or paraphrasing), this knowledge is important in helping a woman to feel validated:

- Abused women need to feel that their thoughts and ideas are of value.

- By really being listened to, the abused woman can let go of denial.

- Active listening promotes bonding.

- It creates trust and builds self-esteem, helping the abused woman out of isolation.

Active listening is a valuable tool developed by Dr. Thomas Gordon in the book, *(P.E.T.) Parent Effectiveness Training*. This skill requires practice because we speak at a rate of 100-150 words per minute and listen at a rate of 400-500 words per minute. This skill might seem awkward at first. Remain optimistic and patient with yourself as you become more competent and have it integrated into your communication patterns. Put the effort into understanding how it works and you will see beneficial results.

Active listening will help an abused woman know that you believe her. It will give her the time and the patience she may need to discuss her abuse. Because her self-esteem is usually very low, any hint of disbelief from you will cause her to doubt her experience. Allow an abused woman to talk about her ambivalence toward her abusive partner. Deinvesting from a relationship is usually quite a struggle.

In active listening the receiver tries to understand the content of the speaker's verbal communication. The receiver phrases what has been understood in her or his own words (code) and feeds it back for the sender's verification and accuracy. The receiver does not respond with an evaluation, opinion, or advice. The listener does not psychoanalyze the sender's statements. For example:

Sender: "I'm feeling so unhappy this week. My boyfriend is really getting destructive. The other day he tore the phone out of the wall."

Receiver: "Can you go into more detail about that?"

Sender: "Every time I do something wrong, he does something to me or the house. He's really stressed out at work. I feel scared after he's done a number on me or the house. He's getting real scary to be around. My girlfriend gave me a Valium last night. I don't seem to be able to calm down."

Receiver: "You're real scared right now. Enough to take a tranquilizer. Is that right?"

Sender: "Yes. I'm depressed a lot. It's as though the motor of my life is turned off. I know this is all coming from our relationship. I feel hopeless. I love him, but I can't stand what he does to my self-esteem and the house. I feel very upset. I didn't go to work today. I stayed in bed all day and cried."

Receiver: "It sounds like your relationship is affecting your whole life. You feel confused because you love him. The relationship is affecting your mind. Did I hear you correctly?"

Sender: "Yes, you did. I appreciate someone listening to me."

Door openers convey an invitation from you to help the abused woman talk or say more:

"Can you go into more detail about that issue for me?"

"I'm listening. I care about what you are feeling right now."

"This seems very important to you and I would like to hear more."

"Tell me more about what he does that makes you so scared."

Avoid Invalidating the Abused Woman's Experience

The abused woman needs skillful questioning. Do not ask questions that are victim-blaming. This woman's reality is often looked upon as a fabrication of her imagination. Her fears may be dismissed as exaggerated paranoia. Because her self-esteem is low, any hint of criticism may cause her to not talk. You must take her story seriously. Let the abused woman know that you believe her. Give her the time and the patience she may need to discuss the abuse. Many abused women will eagerly talk if they feel safe and supported.

Certain remarks and questions can make the abused woman feel invalidated.

"Oh, that's so terrible. I would never let a man beat me up. I wouldn't be around long enough for him to try it again."

This statement implies to the abused woman that she is inferior if she lets a man beat her. It is important to empathize with the battered woman. Acknowledge that she is a strong person for surviving the batterings. Convey that she is a strong person and she deserves respect and support.

"You must be getting something out of being beaten."

A battered woman has little control or power in the situation. To imply that she is masochistic is not helpful. Ask her what she wants for herself. Help her to determine whether these goals can be actualized in this relationship. Work together to find ways of attaining these goals.

"Why don't you leave the jerk?"

"Why" questions are threatening by nature. Help her evaluate the reasons why she should stay or leave him. Listening to her without judgment can help her gain strength to cope with the task of rearranging her life.

"How did you get involved with this kind of man?"

A battered women feels guilty about being beaten. She may consider herself unable to judge character. It is important to reassure her that abusers appear no different from other men. Point out that batterers belong to no specific religious, economic, racial, or geographic subgroup.

Design a Safety Plan with the Abused Woman

You should conduct an assessment with every abused woman. It is important that she fill out the questionnaire (in Supplemental Handouts, page 99). The following behaviors should lead to the development of a "safety plan":

- The abuser uses alcohol or drugs in a state of rage and depression.
- The abuser has extreme rage about the woman leaving.
- The abuser hunts the woman down and harasses her.
- The abuser threatens that the violence will escalate.
- The abuser uses such statements as, "I can't live without you," "I'm going to end it all," "I'll kill you if you leave me."
- The abuser has a past history of homicide or suicide attempts.

It is imperative to tell the abused woman that you are concerned about her welfare. Plan together for her safety. Do not make choices for her. Stress the benefits of leaving:

- Safety from mental and physical abuse for herself and her children
- Increased feelings of control over her life
- A sense of freedom
- Self-respect, self-confidence, and a sense of identity
- Peace of mind

Explore her alternatives carefully. Help her to become aware of her community options. Inform her of shelter, legal, and welfare options. Refer her immediately to abuse programs that are knowledgeable about her rights. If community resources do not exist, call the National Coalition Against Domestic Violence, (202) 638-6388.

Consider the following factors as you discuss a safety plan:

- Does she have reliable transportation?
- Does she have the number to a hotline for abused women?
- Does she know about restraining orders?
- Can you "safely" call her and identify yourself? Is there some sort of code that the two of you could devise?
- What does she think will happen to her if she does leave?
- Does he know the whereabouts of all friends or relatives?
- Whose home might be considered for a safe refuge?
- Whose whereabouts does he know?

- Will she receive warnings that she is being looked for by the abuser?

- What can she do to prevent being found?

- Does she have local and national shelter phone numbers?

- In the event that she must leave hurriedly, does she have an extra set of keys for the house or car?

- Does she have access to money?

- Does she have quick access to important documents like birth certificates, social security cards, car registration, etc.?

Avoid Couples Counseling

Couples therapy endangers the abused woman. It encourages the batterer to blame the victim. By seeing the couple together, you erroneously suggest that the woman is responsible for the batterer's actions.

Never ask the abused woman to discuss the relationship or the abuse in the presence of her assailant. Many women have been severely beaten after a counseling session in which abuse is disclosed. Never ask the assailant to verify her story. Always interview the abused woman separately from her assailant.

BATTERED WOMEN IN SUPPORT GROUPS

Important Phraseology for Group Discussions

- "We will be here for (one, two, three, etc.) (weeks, months) on (day of the week) at (time). The bathroom is located (directions). Our concern is for the confidentiality of each abused woman's experiences. It is very important that you not repeat personal information discussed in this meeting once you leave."

- "You have made a positive step by coming to the first meeting of this support group for abused women. Your presence and participation will add to this group. You are important and can make valuable contributions."

- "Proceed at your own pace. You are not being evaluated and will not be criticized. You can feel safe here."

- "This support group is an opportunity to learn how to take abuse out of relationships."

- "You will not be put on the spot to talk. Participation is voluntary. There will not be forced disclosures from anyone in this group."

- "Can anyone relate to any of these statements?"

- "Is anyone experiencing an abusive relationship right now?"

- "What are your patterns when you get depressed?"

Discussion Guidelines

This guide can be used to stimulate beneficial group discussions that have meaningful content and relevancy to abused women. These ideas are intended only as guidelines. Make adaptations to achieve the greatest possible learning for your group. I encourage you to follow your own wisdom in deciding how to merge these ideas.

1. As a support group facilitator, your role is to be encouraging and positive. Start your support group on a positive note. It's hard for abused women to open up in a negative atmosphere. Initiate participation by asking non-threatening questions, for example: "Would anyone like to share their feelings about coming to the meeting tonight?", "Is there anyone who feels uncomfortable about coming to the meeting tonight?" etc.

2. It is desirable for everyone present to have an opportunity to talk. When everyone has talked, go back to those women who did not contribute, and gently ask if they would like to share. If a women realizes she will not be pushed to participate, she might risk and talk during a support group. A group member should never feel put on the spot to talk. If an abused woman seems unconnected with the group, allow this woman to feel content to remain in eye contact with you and the other women. Let her rest in the sanctuary of the meeting.

3. Your goal in leading a discussion is to create interactive and meaningful discussions that bring abused women out of isolation. Try not to ask questions that can be answered with yes or no. Raise questions that begin with how, which, and why.

4. Respond to an abused woman's questions or comments with acknowledging statements such as: "Thank you for sharing," or, "I'm glad you mentioned that." This is crucial in helping abused women who need verbal reinforcement to open up about their abuse. By establishing a nonthreatening atmosphere, you'll allow abused women express themselves.

5. Abused women have a tendency to advise or try to psychoanalyze one another. They try to solve another abused woman's life to divert their attention from solving their own problems. Abused women are often in a holding pattern as to what they should or should not do. Decisions to have a better life do not come easily. Gently point out when advice giving happens: "Let's think twice before giving advice. Let's put the focus on our own problems."

6. A topic focuses the attention of the support group and provides a sense of coming together for a shared purpose. Topic areas keep group members on the topic. When the discussion seems to meander and get off course, remind participants of the topic at hand.

7. Brainstorming is an effective method for stimulating active participation. Encourage abused women to speak out and express their ideas, without criticism or evaluation. A five to fifteen minute span of time creates a sense of urgency. Record comments on newsprint or on a blackboard. This helps abused women feel that their thoughts are valuable.

8. It is important to achieve a sense of balance in the support group setting. Vary the flow of the support group by having large group, small group, and one-on-one interaction. This creates the opportunity for each woman to have a chance to talk in a different setting.

Special Instructions for Recovery Growth Steps

In this discussion guide you have been provided with a set of cards that will encourage women to relate personal feelings and background histories of abuse (these cards are directly derived from Reading RD 4, and appear on page 102). These cards were designed to guide women to rebuild feelings of control and self esteem. This set of cards and the following ideas will improve the content, relevancy, and participation of your discussion groups. They can also be used in individual therapy. These cards may be copied.

1. As women arrive at the support group, give **each** one a card. Tell each woman to read her card and not share it with anyone. After the support group meeting has begun, ask if anyone received a card that seemed personally meaningful.

2. Have one woman read aloud the entire list of recovery growth steps. Tell group participants that they can spontaneously volunteer comments **after** each step is read. Move the pace of the discussion along until all the steps have been read.

3. In front of the whole group, model **active listening** with a group participant. Explain active listening. Give each woman a card and instruct participants to listen to each other in the mode of active listening as they discuss the relevancy or irrelevancy of their card.

4. Ask one woman to give a personal testimony of a present or past negative relationship. Guide the testimony by interjecting **growth steps** that seem to apply to a woman's statements.

5. Pick one of the steps and stimulate a discussion with the following questions. Record ideas on a blackboard or newsprint and thread the resulting ideas into a discussion. For example:

#7. What do you tend to do or use when you feel upset about your relationship?

#13. What seems to attract you to a negative male? Is he unusually sexy? What are hooks that attract you to these kinds of men? Are they immature, needy, poor?

#15. What are some fun activities that women could do together?

#16. What are personal goals or dreams that you have procrastinated about? What are some of the excuses that you've used to put off these goals?

Abused Women Who Can Sabotage Your Group Discussion

Because your support group should focus on the common needs of all abused women present, it is useful to be aware of women who could get your discussion off its main goal: interaction for abused women who have been isolated. There are three basic types of women you need to be aware of: The Suicidal Woman, The Group Monopolizer, and The Group Helper. At any given meeting, these special subgroups can divert the support group from its basic agenda: learning for **all** abused women who came. These women can force you to learn the secrets of limit-setting in a discussion. Pay attention to these women . . . they can teach you so much.

The following information should provide you with an overview of these women. They can destroy the educational experience of the meeting. Be aware. Handle with skill!

The Suicidal Woman

Pay attention to the needs of the abused suicidal woman. Within your discussion she may mention that she has had thoughts of killing herself. She may mention thoughts of "going to sleep forever" or, "forget the whole world." You will need to talk to this woman after the group meeting. Ask her if she has thought out specific plans to end her life. Beware of signals of being extremely depressed or being unusually "happy." If you are not a professional, suggest that she seek help from a counselor, psychotherapist, or psychologist. Before she leaves the support group session, give her appropriate community resource numbers. Tell her that you are not a professional and that this is a self-help group for women who want to discuss their abuse. Do not be afraid to confront this woman. Tell her that her life is important. Plan your strategy for dealing with the suicidal woman ahead of time.

Helpful Phraseology:

> "You seem to be feeling depressed. Let's get together at the break, or after the support group meeting."

> "I'm really concerned about your comments. I heard them."

> "Before the next support group meeting, you must tell me that you got professional help."

The Group Monopolizer

The group monopolizer may be a manic-depressive that talks too much in group discussion. She may dazzle the support group members with her achievements and present a false front of cheeriness and enthusiasm. It is important to set limits with this type of woman. Talk to her in a calm and direct manner.

Helpful Discussion Phraseology:

> "Terry, tonight might be a listening time for you."

> "It seems that you have so much to say in group. It might be wise to have a counseling session in addition to our group. I can give you the name of an attentive counselor." (Said privately after the meeting.)

> "I must ask you to listen tonight. Each abused woman needs an opportunity to talk."

The Group Helper

This woman presents herself as an ally in leading the group with you. She can appear cool, knowledgeable, and quite together. The group helper is detached from her own needs and often feels compelled to take the focus off herself. She is a great advice giver. She does this to bolster her sense of self. The group helper will not grow if you do not make your role clear: you are the group leader.

Helpful Discussion Phraseology:

> "Pat, I want you to put attention towards your problems."

> "Your advice is very good. What are you dealing with right now?"

> "Jeneen, how would you apply that to yourself?"

Abused Women Need New Reinforcements

Changing abusive relationship patterns is a process that needs positive reinforcement. Each step toward healthy relationships will feel unnatural for the abused woman. She will be trying to eliminate her prior conditioning. The abused woman must learn to listen to her own inner voice as her loyal ally guide in personal interactions with men.

With great probability, the abused woman has had a dysfunctional childhood. She might have been physically, sexually, or emotionally abused. Her ability to enjoy trust or intimacy may have

been damaged. The capacity for trust and intimacy are essential keys for healthy relationships. This capacity defines the ability to participate in a positive relationship.

The abused woman must openly tell the truth about her childhood; it is the imprint that formed her mind patterns about relationships. The abused woman can never experience a healthy relationship until she examines her childhood. She must examine her past script patterns in how they relate to "present" love relationships. It is important for this woman to come out of denial about her past and acknowledge to herself that she did not get the emotional or physical nurturing that she may have needed in her childhood.

Because childhood might have been painful, bewildering or frightening, she learned denial as a form of psychological self-preservation. From childhood conditioning the abused woman was programmed to ignore warning signs of possible abuse. She learned to examine as little as possible, to endure. The abused woman will appear amnesic, unable to remember portions of her childhood. Conditioning messages from childhood are still influencing her life on an unconscious level.

This woman must tear down the walls that she has invented to suppress her dysfunctional childhood. The abused woman must reject the "comfort" of her neurotic past thinking patterns. Many of these women cannot tolerate a positive lifestyle. They reject a situation that contradicts their early conceptions of love. They do not know what love is. Many of these women have never experienced it from their childhood.

By talking about her childhood, the abused woman will achieve cathartic release. It is important to encourage her to express her childhood experiences. It has taken a lot of energy to keep the past within herself. Her energy can now be used for the present. There is significant value for an abused woman to talk within a support group or an individual therapy session. She is taking the first baby steps towards having healthy relationships. She must receive positive reinforcement.

The abused woman must be encouraged to expose the vulnerable aspects of her relationships and her childhood. With "new" reinforcement, this woman has potential to have healthy relationships. She can learn new love patterns for the future chapters of her life. Each woman has so much to teach you about how she learned love. Encourage the abused woman to share her childhood love lessons (or lack of love) by reinforcing her opportunity to talk about them. You can be the link in helping her to deprogram herself from her dysfunctional childhood.

The following are examples of positive reinforcement that you can utilize with abused women. Even though these might seem childish, they can be important tools in helping battered woman to reach new behavior patterns:

1. Acknowledge that women are bonding and opening up to each other. Throw a spontaneous party!

2. After a woman has given her testimony of abuse, reward her verbally and give her a tangible reward such as a flower or a new calendar.

3. After women have worked with an active listening experience, reinforce their effort by giving verbal praise and a tangible reward such as a pencil with sweethearts on it.

4. Following a relaxation visualization, reward women verbally with positive compliments. Hand out a reward that corresponds with the theme of the visualization. For example, after experiencing a self-esteem theme, give out small mirrors.

5. After a discussion about abusive men, give women stickers as a reward for sharing.

6. Before a major holiday or a special day like Christmas or Valentine's Day, acknowledge that these days are advancing. Request each woman to sign and self-address a Christmas or Valentine card for herself. Put on a stamp and mail it close to that special day.

Visualizations — Helping Abused Women to Relax

Constant worry and fear contribute to the enormous physical and emotional exhaustion experienced by abused women. Abused women often do not know healthy ways of reducing their physical and emotional anxiety. The usage of visualization can help. Visualization is an effective tool that can be used in either individual or group therapy.

Some visualization techniques stem from yogic practices that are thousands of years old, and others are the result of research by contemporary psychologists and physicians. Visualization is an inner state of mind. To visualize effectively, persons must put themselves in a state in which they are aware of their inner processes. The individual must temporarily put aside matters that are not directly pertinent to the process of visualization. This means finding a quiet, tranquil place for visualizing.

With practice, it becomes possible to focus on internal stimuli so that strong external stimuli recede from consciousness. Body relaxation is the first step in learning how to visualize. Deep relaxation serves to clear the individual's mind so that concentration may occur. Concentration enables the individual to fix the mind on one thought or image and to hold it there. "Seeing," as used in visualization, involves much more than exciting the cells of the retina. "Seeing" involves more than the eye, it involves the mind. "Seeing" is the ability to train the mind to see internal messages.

Visualization is beneficial in helping battered women who feel overwhelmed with indecision and powerlessness. Battered women tend to blame themselves incessantly. They do not focus on the courageous actions that they have taken to survive. Negative thinking dominates their thinking patterns. Constant worry and self-interrogation contribute to the enormous fatigue that many battered women feel. Visualization can help abused women gain control over their lives. Visualization can help them program positive mental blueprints into their minds.

Abused women can open mental prison doors with visualization. Through visualization exercises, abused women relate positive feedback of heightened self-image, alertness and an overall sense of well-being. Visualization can heighten a woman's motivation to achieve her goals and reduce anxiety. This tool can help abused women direct their minds to work in cooperation with all the new decisions that they will have to make.

Step One

As you use a visualization, expect positive results. Before the meeting, read through the visualization. (See Visualizations, starting on page 77.) Focus on the images that it produces in your mind. Let these images float through your mind like a movie screen. Allow your mind to gain understanding of the content of the visualization. Change the wording and pauses to meet the readiness and interest level of your client or support group. Believe that **you** are the producer.

Each visualization is designed to be read in about ten minutes. Create whatever feels best to you. Select a music tape to play softly as you read, one that will give your experience deeper imagery. **Remember to bring a cassette tape player to the session.**

Step Two

It is impossible to get an abused woman involved in any visualization if she is tense and preoccupied with recent memories of abuse. Her mind must be quiet of mental noise. At the beginning of each visualization, acquaint abused women with the theme of the mental journey: bonding, unity, trust, or release of anxiety. Tell the women to put all writing materials away. Turn down the lighting. Advise women to get into a relaxed body position that will allow oxygen to flow freely throughout the body. Suggest that both feet be on the floor, hands on top of knees, palms upwards. A relaxed body allows the brain to produce clear mental images. Suggest to the women that they take should take several deep breaths, inhaling and then exhaling slowly.

Step Three

Adjust the volume for your musical selection and start reading with a soothing, dramatic voice.

COMPONENTS OF LESSON PLANS

Affirmations

Affirmations can aid battered women in replacing the negative messages of the past with positive messages of recovery.

The battered woman has an imaginary, idealized self, a perfect self. She is usually angry and resentful for not being perfect. She has a difficult time accepting herself as ordinary, or mediocre. She is critical of herself. The word *should* is interwoven in many of her sentences. The battered woman can drive herself hard because it is difficult to accept herself or her life of abuse. She is easily wounded by criticism.

The battered woman does not treat herself with a sense of self-preservation. She can attempt to drive painful anxiety underground with self-destructive addictions: alcoholism, shopping sprees, overeating, compulsive cleaning, drugs, etc. Tension is a great part of the battered woman's existence. She does not feel that she deserves a satisfying life. Her behavior reflects learned helplessness and suffering as a way of life.

An affirmation is a sentence designed to train the mind to think and act positively. It is very important for you to utilize affirmations with battered women. When you introduce an affirmation, say the words with emphasis in your voice. Affirmations are powerful tools that can help you reverse mental patterns.

It is important to help battered women become aware of what they are programming into the 50,000 thoughts of their mental day. Battered women often have negative self-talk. You can help abused women to feel better by helping them understand their negative self-talk. Tell them that affirmations can help them to become their own best friend by pushing away negative thought patterns. State that affirmations can be mentally triggered when situations of fear, worry, or anxiety appear.

Bonding Circle

Abused women can develop bonds of closeness and trust when a support group begins and ends with a circle of women, either sitting on the floor or sitting in chairs, holding hands. This circle can be even more bonding when you, the support group leader, start with an affirmation. (Refer to Lesson Plans, starting on page 27.)

Say the affirmation to the woman to the right of you. Each woman says the affirmation to the woman on her right. After the affirmation is said to you by the woman on your left, start the next affirmation by saying it to the woman on your left.

Hugging Is Important!

Hugging should be an integral part of your support group for abused women. A warm, meaningful embrace can have a beneficial effect on abused women, particularly during times of crisis and tension, and can lift an abused woman's depression. Hugging can stimulate a stronger will to have a positive life.

Researchers have discovered that when a person is touched, the amount of hemoglobin in the blood increases. Hemoglobin is the part of the blood that carries vital supplies of oxygen to all organs in the body.

Allow abused women who feel uncomfortable with touching to keep their comfort zones of space. Tell women that hugging is not mandatory.

Active Listening — an Important Skill for Abused Women

Codependent is a term that describes how a battered woman interacts in her romantic relationships. She lives her life around **his** needs instead of taking care of **her** own needs first. She can break this imbalance in thought focus. Acquiring listening skills is the necessary foundation for overcoming codependent behavior.

Many abused women feel too embarrassed to talk about their relationship to friends or relatives. They will pretend that everything is alright within the relationship. Problems are cloaked with a great deal of secrecy.

Some abused women, on the other hand, will talk compulsively to many different people about their negative relationships. After a while, many of them have used up these contacts and can no longer turn to them when they are in crisis.

In either instance, the abused woman will feel isolated and trapped in her narrow world of abuse and terror.

Many women find it easier to discuss their dysfunctional relationships in the company of other women who have the same shared experiences of abuse. Listening skills can help abused women face the truth about their relationships. They need to share their histories of abuse with each other. Listening is the greatest honor that battered women can give to each other. Attentive listening can make abused women feel acknowledged and validated.

Listening can heighten an abused woman's sense of self. Women in abusive relationships are inclined to give advice, psychoanalyze, and give helpful suggestions. Abused women often believe that they have a lifetime job of solving other people's problems. This type of woman has to assume a more detached stance in life. She can do this by consciously looking at her listening patterns and those of others as well. The active listening method will stop an abused woman who wants to control and put others together. If a woman uses active listening while dating, she will be more ready to choose a positive relationship. Denial systems are broken down as well.

Active listening is a valuable tool to help abused women listen to each other.

ORGANIZATION OF MEETINGS

An Abused Woman's First Support Group Meeting

The safety of the support group can be a sanctuary for an abused and isolated woman. You can encourage abused women to feel relaxed and welcome by creating an atmosphere that is friendly, compassionate, and accepting. Many abused women will approach their first support group meeting with their defenses up. This first meeting is a tentative exploration for women who have experienced domestic violence. Letting other women know that violence has affected their lives can be frightening.

It is important to establish a special bond with the abused women who come to the support group. All abused women in attendance will wonder what the group can do for them and what it will require. Include your credentials, but emphasize the experiential over the academic. If you have not been personally involved in domestic violence, talk about a relative, friend, or co-worker who has suffered from the experience. Knowing that someone else truly understands one's pain, by virtue of having *been there*, brings a sense of relief to the abused women in the group. Suffering is no longer experienced in isolation.

In the group setting, point out to abused women that they may sort out their feelings in a safe and confidential setting. Let them know that there will be no group disapproval for those who stumble in the march toward recovery. Relate that they are not being graded and that they can proceed at their own pace.

Materials Needed for Each Support Group Meeting

- Welcome Packet, to be given to each woman, includes:
 Welcome Letter, page 100.
 Questionnaire, page 101.
 Statistics on Domestic Violence, page 89.
 What is Abuse? page 51.
 You may also include recent news stories or articles related to domestic violence.

- Brochures and pamphlets of interest to abused women.

- Books related to domestic violence. (Refer to Suggested Reading starting on page 103.)

- Extra copies of **Statistics on Domestic Violence.** (Battered women often know other women who are subject to abuse.)

- Location Flyer: Post in building.

- Pens and Pencils.

- Refreshments.

- Cups, napkins, other necessities.

- Tape recorder and musical selections

Guidelines to Lesson Plans

The lesson plans are designed for twelve support group or individual sessions. The format of each lesson plan is quite explicit and structured. The purpose behind each lesson is to be of service to you, to provide you with new ideas for practical application. Adapt them to your specific needs. **Special note: suggestions for individual client usage follow on the next page.**

The lesson plans are designed for easy reference. Each lesson plan presents a certain topic. The outline of each lesson plan is:

Materials

Pre-meeting tasks

 I. Greet women

 II. Opening circle

 III. Reading selections

 IV. Active listening

 V. Visualization or group involvement

 VI. Closing circle

Within each lesson you will find the following **material components** indicated:

Handout

Reading selection

Power Thought

Group involvement (or)

Visualization

Recommended books

Code System for Material Components

Each component has its own specific order system. Before each support group or individual session, you are advised to acquaint yourself with the material components.

RD=Readings 1-23

PT=Power Thoughts A-L

V=Visualizations A-F

H=Handouts 1-10

Suggestions for Working with the Individual Client

For an individual client, utilize the following:

1. Have your client read *Every Eighteen Seconds*. Explain the format of this book. Prompt your client to do the Self-Help Education section that follows each letter.

2. Utilize the Readings and read them with your client.

3. Start the session with a Power Thought.

4. At the beginning or end of a session, help your client relax by reading a Visualization.

5. Give Handouts to your client.

6. For commitment purposes, utilize Reading RD 3; substitute "we" for "I"

7. For new behavior patterns, utilize suggested Reinforcements.

8. Refer the client to the Suggested Reading in a lesson plan.

9. Refer your client to Resources and Helpline Numbers.

LESSON PLANS

LESSON PLAN: What Is Abuse?

Materials:

- Handout: 1

- Reading Selections: 1, 2, 3, 4

- Power Thought: C

- Visualization: B

- Recommended Books: *Battered Wives* by Del Martin and *Sweet Suffering* by Natalie Shainess

Pre-meeting Tasks:

- Locate components of lesson plan

- Arrange chairs in a semicircular arrangement

- Refreshments

- Set up display of books, pamphlets, community resources, relevant news article, etc.

I. Greet Women — Handout 1, Welcome Packet to new women

II. Opening Circle

Affirmations:

- "I can program my life to be positive."

- "I came to learn with you tonight."

Hugs or handshakes

Reading Selections: 1 and 2

Power Thought: C

Opening Questions:

- Can anyone give an example of abuse that she experienced?

- How did it make you feel? Did it make you change?

- Did you tell anyone about the abuse?

Discussion

Thoroughly explain process of Active Listening. Role model at each meeting.

III. Reading Selections: 3 and 4

Discussion

IV. Active Listening

Pair Exercise: (10 minutes)

- What types of abuse have you experienced?

- Why did you stay in an abusive relationship?

Group Exercise:

- What did your discussion partner say?

- What did you hear?

V. Visualization: B

VI. Closing Circle

Affirmations:

- "I can program my life to be positive."

- "I learned with you tonight."

LESSON PLAN: What Is a Male Batterer?

Materials:

- Handout: 3

- Reading Selections: 5, 6, 9, 13

- Power Thought: E

- Group Involvement: Yes

- Recommended Books: *Beyond Survival* by Theresa Saldana; *Men Who Hate Women and the Women Who Love Them* by Susan Forward and Joan Torres.

Pre-meeting Tasks:

- Locate components of lesson plan

- Arrange chairs in a semicircular arrangement

- Refreshments

- Set up display of books, pamphlets, community resources, relevant news article, etc.

I. **Greet Women** —Handout 3, Welcome Packet for new women

II. **Opening Circle**

Affirmations:

- "I have a right to live in peace."

- "I will try to share my honest feelings."

Hugs or handshakes

Reading Selections: 5 and 6

Power Thought: E

Opening Questions:

- Does anyone believe that it is easy to leave an abusive male?

- Has anyone stayed with an abusive male because she believed that it is better for the children to have a father?

- Does anyone believe that drinking causes men to batter?

Discussion

Thoroughly explain process of Active Listening. Role model at each meeting.

III. Reading Selections: 9 and 13

Discussion

IV. Active Listening

Pair Exercise: (10 minutes)

- What made you feel guilty before you left? Did you have the support of your family, friends, or church? For those women who haven't left, what guilt do you anticipate?

- Did or do you believe any of the put-downs he said about you?

Group Exercise:

- What did your discussion partner say?

- What did you hear?

V. Group Involvement

VI. Closing Circle

Affirmations:

- "I have the right to live in peace."

- "I learned with you tonight."

LESSON PLAN: Guilt

Materials:

- Handout: 2
- Reading Selections: 1, 18, 14, 20
- Power Thought: H
- Visualization: C
- Recommended Books: *The Battered Woman* by Lenore Walker; *The Cinderella Complex* by Colette Dowling

Pre-meeting Tasks:

- Locate components of lesson plan
- Arrange chairs in a semicircular arrangement
- Refreshments
- Set up display of books, pamphlets, community resources, relevant news articles, etc.

I. Greet Women — Handout 2, Welcome Packet to new women

II. Opening Circle

Affirmations:

- "I am not the cause of another's violent behavior."
- "I deserve to be treated with respect."

Hugs or handshakes

Reading Selections: 1 and 18

Power Thought: H

Opening Questions:

- Do you believe that marriage is the highest goal for women?
- Did the abuse make you feel that you had failed?
- Did your partner make statements or do things to make you feel guilty for leaving?

Discussion

Thoroughly explain process of Active Listening. Role model at each meeting.

III. Reading Selections: 14 and 20

Discussion

IV. Active Listening

Pair Exercise: (10 minutes)

- What got you initially into the relationship? Was he sexual? Did he give you lots of compliments? Did he seem powerful?

- Do you feel guilty for getting into a relationship with a man who is abusive?

Group Exercise:

- What did your discussion partner say?

- What did you hear?

V. Visualization: C

VI. Closing Circle

Affirmations:

- "I am not the cause of another's violent behavior."

- "I deserve to be treated with respect."

LESSON PLAN: Battered Women

Materials:

- Handout: 5
- Reading Selections: 2, 12, 15, 18
- Power Thought: F
- Group Involvement: Yes
- Recommended Book: *Getting Free* by Ginny NiCarthy

Pre-meeting Tasks:

- Locate components of lesson plan
- Arrange chairs in a semicircular arrangement
- Refreshments
- Set up display of books, pamphlets, community resources, relevant news article, etc.

I. Greet Women — Handout 5, Welcome Packet to new women

II. Opening Circle

Affirmations:

- "I have the right to express how I feel."
- "I am not alone anymore."

Hugs or handshakes

Reading Selections: 2, 12

Power Thought: F

Opening Questions:

- What does a family mean to you?
- What is a healthy family?
- To keep a family together, do you have to stay in a situation where you suffer abuse?

Discussion

Thoroughly explain process of Active Listening. Role model at each meeting.

III. Reading Selections: 15 and 18

Discussion

IV. Active Listening

Pair Exercise: (10 minutes)

- What characteristics of a battered woman can you relate to?

- Do you handle criticism? How does it make you feel?

Group Exercise:

- What did your discussion partner say?

- What did you hear?

V. Group Involvement

VI. Closing Circle

Affirmations:

- "I have the right to express how I feel."

- "I am not alone anymore."

LESSON PLAN: Feelings

Materials

- Handout: 4
- Reading Selections: 4, 5, 8, 17
- Power Thought: B
- Group Involvement:Yes
- Recommended Books:

Pre-meeting Tasks

- Locate components of lesson plan
- Arrange chairs in a semicircular arrangement
- Refreshments
- Set up display of books, pamphlets, community resources, relevant news articles, etc.

I. Greet Women — Handout 4 and Welcome Packet to new women

II. Opening Circle

Affirmations:

- "I deserve the best from life."
- "I deserve to live in a peaceful and safe home."

Hugs or handshakes

Reading Selections: 5, 8

Power Thought: B

Opening Questions:

- Can anyone relate to any of the feelings we just read?
- Is anyone depressed?
- Is anyone feeling overwhelmed with the new decisions you are making (welfare, transportation, money, children, shelter, etc.)?

Discussion

Thoroughly explain process of Active Listening. Role model at each meeting.

III. Reading Selections: 17, 4

Discussion

IV. Active Listening

Pair Exercise: (10 minutes)

- What are you feeling right now?
- What do you feel towards the abusive male in your life?

Group Exercise:

- What did your discussion partner say?
- What did you hear?

V. Group Involvement

VI. Closing Circle

Affirmations:

- "I deserve the best from life."
- "I deserve to live in a peaceful and safe home."

LESSON PLAN: Our Childhoods

Materials:

- Handout: 7

- Reading selections: 7, 9, 10, 16

- Power Thought: A and D

- Visualization: A

- Recommended Book: *The Pleasers: Women Who Can't Say No— and the Men Who Control Them* by Kevin Leman

Pre-meeting Tasks:

- Locate components of lesson plan

- Arrange chairs in a semicircular arrangement

- Refreshments

- Set up display of books, pamphlets, community resources, relevant news article, etc.

I. Greet Women — Handout 7, Welcome Packet to new women

II. Opening Circle

Affirmations:

- "I deserve to feel happy."

- "I am not alone anymore."

Hugs or handshakes

Reading Selections: 7 and 9

Power Thoughts: A and D

Opening Questions:

- Can anyone remember how they were talked to as a child?

- What do you remember your father or mother saying to you?

- Do you remember how a significant sister or brother talked to you?

Discussion

Thoroughly explain process of Active Listening. Role model at each meeting.

III. Reading Selections: 16, 10

Discussion

IV. Active Listening

Pair Exercise: (10 minutes)

- What was your mother like? Did she love you? How did she relate to your father or the men in her life? Was she assertive?

- How are you like your mother?

Group Exercise:

- What did your discussion partner say?

- What did you hear?

V. Visualization A

VI. Closing Circle

Affirmations:

- "I deserve to feel happy."

- "I am not alone anymore."

LESSON PLAN: Our Children

Materials:

- Handout: 6
- Reading Selections: 1,11,18, 21
- Power Thought: I
- Visualization: D
- Recommended Book: *The Burning Bed* by Faith McNulty

Pre-meeting Tasks:

- Locate components of lesson plan
- Arrange chairs in a semicircular arrangement
- Refreshments
- Set up display of books, pamphlets, community resources, relevant news articles, etc.

I. Greet Women — Handout 6, Welcome Packet to new women

II. Opening Circle

Affirmations:

- "I have control over my life."
- "I have the right to be proud of myself."

Hugs or handshakes

Reading Selections: 1, 11

Power Thought: I

Opening Questions:

- What are some problems that you are facing with your children?
- How are they affected by the abuse?
- How did you envision your mothering to be like? Has your dream of motherhood been affected by the abuse?

Discussion

Thoroughly explain process of Active Listening. Role model at each meeting.

III. Reading Selections: 18, 21

Discussion

IV. Active Listening

Pair Exercise: (10 minutes)

• What do you feel your children deserve? If you have no children, what does a child need to feel loved?

• Is it right to break up a family when a man is abusive? What should and shouldn't be tolerated?

Group Exercise:

• What did your discussion partner say?

• What did you hear?

V. Visualization: D

VI. Closing Circle

Affirmations:

• "I have control over my life."

• "I have the right to be proud of myself and who I am."

LESSON PLAN: Depression

Materials:

- Handout: 9
- Reading Selections: 4, 5, 8, 23
- Power Thoughts: A and K
- Group Involvement: Yes
- Recommended Book: *The Book of Hope* by DeRosis

Pre-meeting Tasks

- Locate components of lesson plan
- Arrange chairs in a semicircular arrangement
- Refreshments
- Set up display of books, pamphlets, community resources, relevant news articles, etc.

I. Greet Women — Handout 9, Welcome Packet to new women

II. Opening Circle

Affirmations:

- "All areas of my life are changing for the better."
- "I have the right to express how I feel."

Hugs or handshakes

Reading Selections: 8, 23

Power Thoughts: A and K

Opening Questions:

- Does anyone feel depressed?
- Why do we feel ashamed when we feel depressed? Does it hurt the perfect image we want to present to others?
- Who can you go to when you are feeling depressed?

Discussion

Thoroughly explain process of Active Listening. Role model at each meeting.

III. Reading Selections: 5 and 4

Discussion

IV. Active Listening

Pair Exercise: (10 minutes)

- What do you do when you feel depressed? Do you withdraw from people?

- In your life what goals seem destroyed because of the abuse?

Group Exercise:

- What did your discussion partner say?

- What did you hear?

V. Group Involvement

VI. Closing Circle

Affirmations:

- "All areas of my life are changing for the better."

- "I have the right to express how I feel."

LESSON PLAN: Anxiety

Materials:

- Handout: 10
- Reading Selections: 1, 3, 8, 17
- Power Thought: H
- Visualization: E
- Recommended Book: *Find Your Perfect High* by John Marshall

Pre-meeting Tasks:

- Locate components of lesson plan
- Arrange chairs in a semicircular arrangement
- Refreshments
- Set up display of books, pamphlets, community resources, relevant news articles, etc.

I. Greet Women — Handout 8, Welcome Packet to new women

II. Opening Circle

Affirmations:

- "I am a worthwhile woman."
- "I can take care of myself."

Hugs or handshakes

Reading selections: 1, 8

Power Thought: H

Opening Questions:

- Does anyone feel anxious or stressed?
- When you felt scared about his abusive behavior, what did you do or use to work through the anxiety?
- Can anyone isolate the feelings of what it is like to live in an abusive home?

Discussion

Thoroughly explain process of Active Listening. Role model at each meeting.

III. Reading Selections: 17, 3

Discussion

IV. Active Listening

Pair Exercise:　(10 minutes)

- What are you trying to problem solve right now?

- Do you feel optimistic or negative about your problems?

Group Exercise:

- What did your discussion partner say?

- What did you hear?

V. Visualization: E

VI. Closing Circle

Affirmations:

- "I am a worthwhile woman."

- "I can take care of myself."

LESSON PLAN: Leaving Plans

Materials:

- Handout: 7

- Reading Selections: 4, 9, 19, 22

- Power Thought: A and L

- Group Involvement: Yes

- Recommended Book: *How To Change Your Name* by David Brown and David Ventura

Pre-meeting Tasks:

- Locate components of lesson plan

- Arrange chairs in a semicircular arrangement

- Refreshments

- Set up display of books, pamphlets, community resources, relevant news articles, etc.

I. **Greet Women** — Handout 7, Welcome Packet to new women

II. **Opening Circle**

Affirmations:

- "I am an important human being."

- "I can cope with changes in my life."

Hugs or handshakes

Reading Selections: 9 and 19

Power Thoughts: A and L

Opening Questions:

- If you had to leave again, what important documents or things would you have quick access to? (Prompt women to include: birth certificates, social security cards, car registration, extra set of house/car keys, money, credit cards, children, etc.)

- Has anyone left more than one time? What would you do differently if you were in an abusive relationship?

- Did anyone leave a lot behind when they left?

Discussion

Thoroughly explain process of Active Listening. Role model at each meeting.

III. Reading Selections: 4, 22

Discussion

IV. Active Listening

Pair Exercise: (10 minutes)

- What makes you want to leave? What does he do or say?

- Have you thought about a "leaving plan"?

Group Exercise:

- What did your discussion partner say?

- What did you hear?

V. Group Involvement

VI. Closing Circle

Affirmations:

- "I am an important human being."

- "I can cope with changes in my life."

LESSON PLAN: Positive Thinking

Materials:

- Handout: 8

- Reading Selections: 1, 2, 11, 14

- Power Thought: G

- Visualization: F

- Recommended Books: *Prospering Woman: A Complete Guide to Achieving the Full Abundant Life* by Ruth Ross; *Daily Affirmations for Adult Children*, by Rokelle Lerner

Pre-meeting Tasks:

- Locate components of lesson plan

- Arrange chairs in a semicircular arrangement

- Refreshments

- Set up display of books, pamphlets, community resources, relevant news articles, etc.

I. Greet Women — Handout 8, Welcome Packet to new women

II. Opening Circle

Affirmations:

- "I forgive myself for letting someone hurt me."

- "I am capable of changing."

Hugs or handshakes

Reading Selections: 1, 2

Power Thought: G

Opening Questions:

- Does anyone here use negative self talk? Has anyone ever said rotten things to themselves like, "You stupid jerk," "Why did I say that to him?", "I sure know how to pick rotten men," etc.

- Does anyone here try not to use "negative self talk"? Can anyone here forgive herself when she has made a mistake?

- What are positive statements that we could say to ourselves?

Discussion

Thoroughly explain process of Active Listening. Role model at each meeting.

III. Reading Selections: 14, 11

Discussion

IV. Active Listening

Pair Exercise: (10 minutes)

- How do you talk to yourself when you have made a mistake? Are you supportive of yourself?

- Are you generally depressed or optimistic?

Group Exercise:

- What did your discussion partner say?

- What did you hear?

V. Visualization: F

VI. Closing Circle

Affirmations:

- "I forgive myself for letting someone hurt me."

- "I am capable of changing."

LESSON PLAN: What Is Love?

Materials:

- Handout: 5
- Reading Selections: 5, 14, 16, 17
- Power Thoughts: A and J
- Group Involvement: Yes
- Recommended Book: *The Road Less Traveled* by M. Scott Peck

Pre-meeting Tasks:

- Locate components of lesson plan
- Arrange chairs in a semicircular arrangement
- Refreshments
- Set up display of books, pamphlets, community resources, relevant news article, etc.

I. **Greet Women** — Handout 5, Welcome Packet to new women

II. **Opening Circle**

Affirmations:

- "I am willing to accept love"
- "I am a worthwhile person"

Hugs or handshakes

Reading Selections: 16, 17

Power Thought: J

Opening Questions:

- What is love? Refer to *The Road Less Traveled*, chapter 2. (Guide conversation to the components of love: ability to listen, commitment, encouragement, attention, steadfast caring, etc.)
- Does anyone feel she loves her abusive partner? Why?
- Does great sex mean love?

Discussion

Thoroughly explain process of Active Listening. Role model at each meeting.

III. Reading Selections: 5, 14

Discussion

IV. Active Listening

Pair Exercise: (10 minutes)

- What qualities do you look for in a good friend? Loyalty, ability to listen?
- Do you get these qualities with the men you pick?

Group Exercise:

- What did your discussion partner say?
- What did you hear?

V. Group Involvement

VI. Closing Circle

Affirmations:

- "I am willing to accept love."
- "I am a worthwhile person."

READINGS

RD 1. Our Contract

I want to make positive changes in my life.

I agree to look at taking responsibility for the events of my life.

I agree to look at whatever is between me and having a positive life.

I am willing for Group to be an educational experience.

I agree to be on time to a support group meeting. I will not use alcohol or drugs before a support group meeting. I will be asked to leave if this is suspected.

I am willing to have a positive life.

I acknowledge that this support group does not intend to replace other skilled professionals like counselors or psychotherapists.

I will make an effort to speak about my inner feelings, even if they make me feel uncomfortable.

I acknowledge that I am not here to please others and know that I am not being evaluated.

I will not compare my life with another abused woman in the group. My development is totally unique.

I will keep my focus on myself.

I will not repeat anything said in this support group to anyone "outside."

I will keep all interactions confidential. I will not disclose the names or identities of any women within this group.

I acknowledge that my thoughts materialize my future destiny.

No one can limit my future except me.

RD 2. What Is Abuse?

"Abuse" will be used in this definition to indicate violence inflicted upon a woman by a man with whom she is married or cohabiting. Abuse can be found among married and unmarried heterosexuals, lesbians and gays. It cuts across geographic, religious, economic, and racial barriers. Abuse is a pattern of control that a man exercises that physically harms, induces fear, prevents a woman from doing what she wishes, or forces her to perform in ways she does not want to. Abuse includes physical, sexual or emotional attacks.

Physical abuse is: A) pushing, scratching slapping, hitting, punching, choking, kicking, holding, biting, or throwing; B) locking you out of the house, driving recklessly when you are

51

in the car, throwing objects at you, threatening to hurt you with a weapon, abandoning you in dangerous places, refusing to help when you are pregnant, injured, or sick.

Emotional abuse is: ignoring your feelings, ridiculing your beliefs, withholding approval, threatening to take your children, telling you about his affairs, manipulating you with lies, threatening to leave you, taking the car keys or money, keeping you from working or going to school, humiliating you in public or private, abusing your pets or children, calling you names, or driving your family or friends away.

Sexual abuse is: insisting that you dress in an uncomfortable sexual way, calling you sexual names like "whore," "bitch," forcing you to strip, forcing unwanted sexual acts, withholding sex, criticizing you sexually, insisting on unwanted touching, assuming you would have sex with any available man.

RD 3. I Have the Right

1. I have the right to be in a safe, nonviolent home. I do not have to accept physical, emotional, or sexual abuse.

2. I have the right to make mistakes. I do not have to be told that I am inadequate.

3. I have the right to make my own decisions and be respected for my intelligence. I have the right to pursue my own interests.

4. I have the right to focus on my needs. I do not have to participate in a relationship that does not encourage my well-being.

5. I have the right to challenge another and to discuss the problems this person's behavior creates for me.

6. I have the right to believe that I have a good memory and can remember events accurately.

7. I have the right to change my own mind.

8. I have the right not to answer a question.

9. I have the right to care for myself. I do not have to feel guilty or responsible. I am not obligated to fulfill the needs of a man who was mistreated emotionally or physically by his parents, served time in jail or has a drug or drinking problem.

10. I have the right to have a man arrive on time. I do not have to accept excuses for behavior that is inexcusable.

11. I have the right to express how I feel. My feelings are important and deserve to be listened to.

12. I have the right to have trust agreements kept with me regarding my body, my emotions, and my child or children.

13. I have the right to have a man who is sexually faithful.

14. I have the right to participate in the process of making rules that will effect my life.

15. I have the right to be proud of myself and my achievements.

16. I have the right to provide a healthy environment for myself and my child or children.

RD 4. Recovery Growth Steps

1. I will let go of my personal denial which inhibits me from being truthful about abuse. I will closely examine how abuse has affected my life.

2. I will admit to at least one woman that my relationship has been painful. I will admit that I have been abused. I will admit that my brain has responded with helplessness, depression, hopelessness, denial, guilt, indecision, resentment, and/or neglectful parenting.

3. I will admit that I have spent a lot of time badgering my abusive partner to break down his defenses so he can listen to me. To control a relationship, I have used mental or sexual manipulation, nagging, submission, or psychoanalyzing.

4. I will not dwell on my past mistakes. I can learn from my past involvement in domestic violence. I will let go of my inclination to criticize myself for the abuse.

5. I will give myself acknowledgment and positive reinforcement.

6. I will stop looking for men who have intimacy problems. I will be watchful and cautious of my need to be involved with these kinds of men. I will not set myself up to suffer or be a martyr to a man who verbally or physically abuses me.

7. I will be watchful for how abuse predisposes me to addictions: spending too much, eating too much, cleaning too much, drinking too much, taking drugs, or smoking too many cigarettes.

8. I will focus on myself. I will initiate and incorporate into my life a supportive network of people who are capable of giving healthy love.

9. I will learn how to release others so they can live their own lives.

10. I will admit that it is okay for me to express anger. I will learn positive anger skills. I do not have to be quiet when I am angry. I do not have to submit to be verbally or mentally assassinated by an angry or stressed-out male.

11. I will stop procrastinating about what is important for my future and my happiness.

12. I will not involve myself in relationships that are abusive and do not encourage my well-being.

13. I will take time to get to know the man I am considering for a close relationship. I will explore my friendship with a man first, before we become involved in a relationship. I will not decide impulsively that he is "just what I have always wanted," and will wait to see if he can be a friend and keep trust agreements. I will examine whether I am "getting something" out of a possible relationship.

14. When I am in a relationship, I will not try to devote all my time to making it work. My expectation is that a man will also put effort into the relationship. I will restrain myself from hoping that all my needs can be taken care of by a man who has interpersonal problems.

15. I will strive to know what I want in life and that I must give myself happiness. I will develop my happiness from within and will not allow a man to lead me away from my supportive friends or relatives.

16. I will never settle for abuse again.

RD 5. To Lois in Memory of her Divorce, by Nancy Kilgore

My child eyes "once" saw you
As the *giant* man
Who kept my words locked inside
A new woman is being born . . .

"That really bothers me."

You robbed me of my right to form
The syllables to the words of anger
By not listening
And abandoning me when I was torn

"Your inability to listen invalidates me."

Every birth is bloody
This one has been for me
My yesterday silence causes me to mourn
The flashbacks replay how my scars got formed

"It seems that you always disagree with me."

The new birth canal has labored
To let me see the light
That silence and fear can be reformed
A new woman is being born . . .

"You had no right to do that to me."

My new courageous mind
Knows that "freedom of speech" applies to me
My anger is no longer locked inside me
A *giant* woman's mouth has been born . . .

"I have rights, don't even think about hitting me!"

RD 6. A Credo for My Relationship with You

You and I are in a relationship which I value and want to keep. Yet each of us is a separate person with his own unique needs and the right to try to meet those needs. I will try to be genuinely accepting of your behavior when you are trying to meet your needs or when you are having problems meeting your needs.

When you share your problems, I will try to listen acceptingly and understandingly in a way that will facilitate your finding your own solutions rather than depending upon mine. When you have a problem because my behavior is interfering with your meeting your needs, I encourage you to tell me openly and honestly how you are feeling. At those times, I will listen and then try to modify my behavior, if I can.

However, when your behavior interferes with my meeting my own needs, thus causing me to feel unaccepting of you, I will share my problem with you and tell you as openly and honestly as I can exactly how I am feeling, trusting that you respect my needs enough to listen and then try to modify your behavior.

At those times when either of us cannot modify his behavior to meet the needs of the other and find that we have a conflict-of-needs in our relationship, let us commit ourselves to resolve each such conflict without ever resorting to the use of either my power or yours to win at the expense of the other losing. I respect your needs, but I also must respect my own. Consequently, let us strive always to search for solutions to our inevitable conflicts that will be acceptable to both of us. In this way, your needs will be met, but so will mine—no one will lose, but rather both will win.

As a result, you can continue to develop as a person through meeting your needs, but so can I. Our relationship thus can always be a healthy one because it will be mutually satisfying. Each of us can become what he is capable of being, and we can continue to relate to each other with feelings of mutual respect and love, in friendship and in peace.[1]

[1] From *P.E.T. Parent Effectiveness Training,* by Thomas Gordon, PhD. McKay. Reprinted by permission.

RD 7. Programmed Messages from Our Childhood

- Shame on you for thinking that!
- Why don't you act like a nice girl?
- I'm always sacrificing for you, and you are so ungrateful!
- You're driving me crazy with what you want!
- No talking back to me.
- I don't care how you feel.
- Don't get angry with me. I'll give you something to get angry about.
- Don't cry so much. It bothers me.
- Why don't you do it this way?
- Can't you get anything done on time?
- Hurry and grow older. I can't wait until you move out.
- You're not good enough to do that. Quit thinking so big.
- I wish that you had never been born.
- I don't want to hear you.
- Don't get so emotional.
- Don't ask so many stupid questions.
- Don't tell other people about this family's business.
- Just look at my directions.
- You're so self-centered.
- Don't discuss the family with outsiders.
- You caused all your problems.
- We won't love you if you do that.
- You'll never get anywhere.
- It didn't really hurt you that bad.
- I don't believe you.

RD 8. Feeling Guides

Note to facilitator: Prompt participants or client to say "I feel," before reading out loud the group of feelings (1 through 8). The whole group of feelings can be read by eight designated women. Inquire if any of these feelings can be identified as a present "feeling" experience.

Start each word with *I Feel:*

[1]
Lonely
Depressed
Lost
Empty
Discouraged
Rejected
Disappointed
Hurt
Crushed
Drained
Vulnerable
Used
Confused
Bored
Shy
Abused
Down
Sad

[2]
Happy
Amused
Delighted
Pleased
Cheerful
Grateful
Surprised
Relieved
Hopeful
Enthusiastic
Elated
Glad
Excited
Turned On

[3]
Caring
Loving
Sympathy
Pity

[4]
Competent
Confident
Determined
Proud
Fulfilled
Capable
Needed
Secure
Important
Appreciated

[5]
Blocked
Trapped
Burdened
Smothered
Overwhelmed
Frustrated
Torn
Driven
Exasperated

[6]
Panicky
Frightened
Anxious
Threatened
Scared
Worried
Afraid

[7]
Embarrassed
Ashamed
Humiliated
Helpless
Ignored
Neglected
Doubtful
Unimportant
Regretful
Unsure
Intimidated
Uncertain
Left Out
Unappreciated
Insecure

[8]
Mad
Angry
Hostile
Furious
Hateful
Bitter
Irritated
Resentful
Jealous
Envious
Disgusted
Cheated
Agitated
Upset
Offended
Slighted

RD 9. National Statistics on Domestic Violence

- In 1985, over 1,300 women were killed by a husband or boyfriend, which was 30% of the total homicides of females; 6% of the male victims of homicide were killed by their wives or girlfriends. (Federal Bureau of Investigation. (1986). *Uniform Crime Reports: Crime in the United States.* 1985. Washington, DC: U.S. Department of Justice)

- Approximately 37% of pregnant patients, across class, race, and educational lines, are physically abused. (Helton A, McFarlane J, Anderson E. Battered and pregnant: a prevalence study. *Am J Public Health.* 1987: 77: 1337-1339)

- Four million women are severely assaulted per year. (Langan Pa, Innes CA. *Preventing Domestic Violence against Women.* Washington, DC: US Department of Justice, Bureau of Justice Statistics: 1986)

- Over one-third of assaults to women involve severe aggression such as punching, kicking, choking, beating up, or using a knife or a gun. (Langan Pa, Innes CA. *Preventing Domestic Violence against Women.* Washington, DC: US Department of Justice, Bureau of Justice Statistics: 1986)

- From one-fifth to one-third of all women will be physically assaulted by a partner in their lifetime. (Frieze I H, Browne a. Violence in marriage. In: Ohlin L, Tonry M, eds. *Family violence: Crime and Justice*, a Review of Research. Chicago, Ill: University of Chicago Press; 1989: 163–218)

- The rate of injury to women from battering surpasses that of car accidents and muggings combined. (McClear SV, Anwar RA. The role of the emergency physician in the prevention of domestic violence. *Ann. Emerg. Med.* 1987: 16: 1155-1161)

- Approximately 95% of the victims of battering are women. (Bureau of Justice Statistics, Report to the Nation on Crime and Justice: The Data, Washington, DC: Office of Justice Programs, US Department of Justice, October 1983)

- Twenty-one percent of all women who use the hospital emergency surgical service are battered. (Stark, E. *Wife abuse in the medical setting: an introduction for health personnel.* (Monograph ser. No. 7) Rockville, MD, National Clearinghouse on Domestic Violence, April 1981)

RD 10. Building Self-esteem

Improving your self-esteem is not an overnight process. It is a gradual, cumulative process that represents evolutionary changes in the way you see yourself. Expecting yourself to be ideal or perfect is a setup for failure. But expecting yourself to be better is a motivation for self-improvement.

The method for moving yourself closer to your ideal self is called the "act as if" approach. The most direct way to change your personality is to act as if you were the way you want to be. In relatively short order, your mind will follow your behavior.

Let's assume that you would feel much better about yourself if you were more confident. The first step is to break the concept of "more confident" down into quantitative, measurable, and concrete behavioral terms.

In building self-esteem, it is vitally important to ensure success. Therefore, *set your goals at attainable, realistic levels.* Start by imagining how you would be different if you were 10 percent more confident tomorrow than you are today. How would you act differently? What kinds of behaviors, including verbal behaviors, would you do if you were 10 percent more confident? It is essential that you specify your goal in action terms.[2]

RD 11. Positive Phraseology For Our Children

How we incorporate our words in sentences is one of the main ingredients in fulfilling or unfulfilling relationships with our children. The following are phrases which foster positive parenting. You might consider incorporating them into your communication patterns.

- "I feel deeply about this issue."

- "Your point of view is something I want to hear."

- "I want to solve this together."

- "Let's both have a little time to think about this problem."

- "I respect your reasons."

- "Educate me about what you know about this."

- "May I share how I feel with you?"

- "Tell me what you would do if you were in my shoes?"

- "What are some of your options?"

- "I need to study your information."

- "Your behavior is having an impact on me. I feel (uneasy, angry, anxious)."

- "Can you help me understand why this is important to you?"

- "I'm listening to your words."

- "Our relationship is something I care about."

- "I want to respect your feelings."

- "How do you feel right now?"

[2] From *Getting Up When You're Feeling Down: A Woman's Guide to Overcoming and Preventing Depression,* Harriet Braiker, G. P. Putnam's Sons. Reprinted by permission.

RD 12. Characteristics of Many Abused Women

For clarity in these descriptions, "husband" is analogous to "cohabitant," "partner;" "relationship" to "marriage."

1. Abused women are found in all socioeconomic levels, all educational, and all racial groups.

2. The abused woman has a martyr-like behavior; she is often a long sufferer and overloaded with the demands of others. The abused woman has difficulty nurturing herself and feels unappreciated.

3. She is often employed but is not allowed control of any finances.

4. The abused woman doesn't know how to deal with stress; she can have anxiety attacks. Usually this type of woman will feel tired and overworked. She doesn't provide enough space in her life for breaks; poor management of time and resources are quite apparent; it's hard for her to make life changes. Problem solving is very stressful.

5. She accepts "responsibility" for the batterer's violent behavior.

6. The battered woman is isolated and loses contact with her family or friends; she often feels embarrassed about her situation. This type of woman is further isolated because her partner doesn't want her to give time to friends, neighbors, relatives, or outside activities. He wants all the attention himself.

7 She suffers from guilt; this woman may feel that she deserves to be beaten because she is not able to live up to her husband's expectations.

8. The abused woman is a traditionalist about her role in the home; she strongly believes in family unity, has traditional expectations of husband or cohabitator as the provider. This type of woman often doesn't like her role and can "nag". She wants to keep the image of a socially or religiously acceptable marriage.

9. The abused woman has a low self-esteem and doesn't feel that she has much value. She is extremely critical of herself and usually of others. She doesn't have a high level of self-preservation.

10. Accepts violence in hopes of that someday she will be able to change mate. She believes that she caused the anger and violence. She usually loves her husband and wants to trust his promises that he'll reform, although this rarely happens.

11. She was emotionally neglected as a child; she was physically and/or sexually abused as a child or saw violence in her family. She could have been abused by a sibling, parent, or a relative.

12. It's difficult for the battered woman to verbalize her needs and desires to others. She has poor communication skills and has difficulty in being able to express her anger. Because she is unassertive, she can be quite manipulative. She is skilled in the art of complaining. Her complaints are usually not listened to or resolved by her partner.

13. This woman's mind is often in denial; she often will not admit to herself that she has been physically, emotionally, or sexually abused. The abused woman may think of each incident as an "accident." She often gives herself excuses for her husband's violence. The abused woman is a great rationalizer: "He's not so bad. He's a great provider."

14. From her childhood she was taught to defer power to a male. Much of the time she feels helpless and will look for someone to help her put her life together. She does not want to take responsibility for making decisions and would rather have someone else make them. Many abused women feel comfortable in taking a "compliant" position; she has been brought up to believe that women are weak, inferior and should submit to men in return for financial support.

15. This type of woman has sexual problems because of unresolved anger toward her abusive husband. She receives a great deal of further abuse for not performing like she used to.

16. The abused woman is often depressed. She can try to make herself less depressed with alcohol, drugs, shopping sprees, overcleaning, overeating, etc. She can contemplate suicide.

17. She is at high risk of being hit on the face or head area; during pregnancy she may be hit in the abdomen.

18. The abused woman is unable to convince her partner that accusations about her cheating on him are untrue.

19. Because she is being hit by her partner, she can hit her own child(ren) and then feel extremely sorry.

20. The abused woman is usually willing to "mother" an emotionally immature man; she is willing to sacrifice and not expose his inexcusable abuse towards her, her children, friends, relatives, property, pets. These women feel that they are expected to act more like mothers than wives.

RD 13. Characteristics of Many Male Batterers

For clarity in these descriptions, "wife" is analogous to "cohabitant," "partner;" "relationship" to "marriage."

1. He is found in all socioeconomic levels, all age groups, and all racial groups. Many batterers have police records.

2. He has a low self-esteem. Many are insecure about their worth as providers, husbands, or sexual partners.

3. He blames others for his actions; he has poor impulse control and can have explosive temper outbursts. He has a low tolerance for frustration.

4. He doesn't believe his violent behavior should have negative interpretations; he has no awareness of, or guilt for, violating his wife's boundaries.

5. He has a family history of domestic violence; he witnessed a "significant other" being physically or emotionally abused. The batterer has not acquired the necessary social lesson that beating up a woman is wrong.

6. He can employ some of the following weapons, besides fists and feet: guns, knives, a broom, a belt, a brush, a pillow (to smother), a hot iron, lighted cigarettes.

7. His expectations of relationship are unrealistic: he expects his wife to conform to his fantasies; his expectations are often unspoken. He has insatiable childlike needs and believes that his partner or children "ought to" be this and this, do that and that. The batterer is often not satisfied with the efforts of those he lives with; he often says that he has been let down.

8. He is emotionally dependent on his wife and children; when his partner threatens separation, he can exert control over his mate by threatening homicide and/or suicide.

9. Has high level of job dissatisfaction, underemployment, or unemployment that leads to feelings of inadequacy and inability to provide for family according to societal stereotypes.

10. He has poor communication skills and accepts violence as a viable method of problem solving; the abuser sees it as an acceptable means of maintaining a family. He makes sure that his partner will not escape by keeping car keys, money, ripping the phone out of the wall, etc.

11. He can have an unpredictable and confusing personality.

12. He is a traditionalist believing in male supremacy in the family; batterers think that they are in charge, and that women should be submissive and content to be controlled. Abusive males believe that their forcible behavior isn't a crime; it is aimed at keeping the family intact. He frequently keeps his partner isolated from society—as well as from friends, neighbors, and even family.

13. He tends to be jealous and can make accusations against mate that he has been "cheated on." He can voice great fear that his partner will abandon him. The batterer can employ clever espionage tactics against his mate: checking the gas mileage when his partner does errands, eavesdropping on his partner's telephone conversations, etc.

14. He can plead that his violent behavior has great potential for reform; he can make many promises and then forget that he made them.

15. He can inflict invisible injuries, mostly to the head and then the face. Many abusers can cause injury to the abdominal area during pregnancy.

16. Those closest to him know that he is characterized by depression and self-pity. The batterer often feels that no one cared about him in his childhood. He believes that his marriage is not providing the caring he needs right now.

17. His use of alcohol or drugs is sometimes associated with the abuse of his partner; it is often used as excuse rather than a cause.

RD 14. What Is a Good Relationship?

1. A good relationship is one where intimacy develops slowly from a friendship to a commitment. You participate with a man who is capable of a fulfilling intimate relationship. He doesn't have deep emotional scars from his childhood or a previous relationship. He is capable of trusting and being trusted.

2. A good relationship is one that is based on a commitment. You feel secure about the future of the relationship. There is no confusion or fear of abandonment. You do not have to cling to the man in your life for fear that he will want to pull away. You feel relaxed and are not anxious about losing the relationship.

3. A good relationship is one where two people do not need each other. They are already individually strong—the relationship enhances their lives. There is consistent sharing of pleasurable activities. You are not constantly disappointed or irritated by your partner's destructive habits—alcoholism, affairs, drug abuse, or physical violence.

4. A good relationship is a partnership that is based on friendship and respect. Your partner is your good friend, who encourages you to become your best. No one acts superior to the other. No one has to beg or plead. Parenting philosophies about discipline are collaborative and negotiated with the other.

5. A good relationship is one where there is a true intimacy of revealing and sharing yourself with your partner as he reveals and shares himself also. There is trust and concern about each other's welfare and happiness. You can openly talk about your needs. You are listened to.

6. A good relationship is one where two individuals can resolve conflict in a peaceful and calm manner. Feelings can be openly expressed. Conflicts are resolved by coming to a compatible agreement. There is no right or wrong person if the agreed decision does not work out satisfactorily.

7. A good relationship is one where both individuals see themselves as partners. There is good communication; there are feelings of closeness and joy. Both partners believe that they can gain far more by remembering to keep agreements. There is no need to dominate and compete with each other.

8. A good relationship is one where two people maintain an enthusiasm about the other's hobbies, work, and friends. You can focus on your daily lives and the needs of your child(ren).

9. A good relationship is one where each partner has a circle of friends and interests outside the relationship. You are not isolated.

10. A good relationship is one where there is talk of a future together. You feel reassured by the relationship's steadfast constancy. You feel cherished and you feel contentment. You maintain your personal dignity.

11. A good relationship is one where both parties balance each other in taking actions to make the relationship work. You are not a martyr.

RD 15. Guilt

You feel guilty when you (a) accept full or major responsibility for a negative event or outcome in your own life or someone else's, and (b) you invoke the reprimand that you "should" or "shouldn't" have done or said something. In some cases, specifically where issues of morality apply, guilt may be appropriate. In other words, if you indeed have violated a moral dictate or legal statute and as a direct consequence caused harm to yourself or another person, it is appropriate to suffer pangs of conscience and remorse, especially if their effect is to deter you from repeating the violations in the future.

But more often than not, your guilt probably is inappropriate and essentially useless. In particular, your guilt is inappropriate when it is based on your assumption of responsibility for people or things for which you are not, in fact, responsible. In this sense, guilt springs from an excessive and misplaced sense of responsibility. Or guilt can develop from the "should" admonition that is directed toward unrealistic, perfectionistic, and unattainable standards for judging your performance and behavior. Generally, guilt serves little purpose other than self-punishment. But this purpose it serves as well as any self-inflicted mental torment. Guilt feels awful and almost invariably brings on feelings of depression.[3]

RD 16. Jan

Jan was married at seventeen, right after high school graduation, and has worked and attended school for most of her married life. Her husband, Ron, was often unemployed and floundering in his career as a salesperson. Jan, at twenty-four, is an exceptionally assertive person, and has been as long as she can remember. No one would have called her dependent at the time of her marriage, yet now she has questions about that. "I would say I was not dependent. Yet I felt the only way I could get out of that situation (living with her mother and a violent stepfather) was to marry someone. I didn't think I could get out by myself. I was feeling real scared, even though everyone said, 'Oh, Jan, she's such a strong person'."

Jan, in fact, was the dominant person in the relationship with her husband. She was the worker, the planner, the organizer. Unlike many abused women, she was neither socially isolated nor economically dependent. She was convinced that she could overcome the marital difficulties by "persistently loving Ron and talking to Ron." "He didn't hit me all that often, at most, six times a year. Sometimes, he might go five or six months, so that gave me hope. I was very much afraid of his outbursts, his uncontrollable anger."

Jan left him several times, once for nine months, after which he didn't hit her for two years. But when it happened again, she left him for good. She has made a very satisfying single life for herself.[4]

[3] From *Getting Up When You're Feeling Down: A Woman's Guide to Overcoming and Preventing Depression,* Harriet Braiker, G. P. Putnam's Sons. Reprinted by permission.

[4] From *The Ones Who Got Away: Women Who Left Abusive Partners,* by Ginny NiCarthy, Seal Press. Reprinted by permission.

RD 17. Honoring the Self

Of all the judgments that we pass in life, none is as important as the one we pass on ourselves, for that judgment touches the very center of our existence.

. . . No significant aspect of our thinking, motivation, feelings, or behavior is unaffected by our self-evaluation.

The first act of honoring the self is the assertion of consciousness: the choice to think, to be aware, to send the searchlight of consciousness outward toward the world and inward toward our own being. To default on this effort is to default on the self at the most basic level.

To honor the self is to be willing to think independently, to live by our own mind, and to have the courage of our own perceptions and judgements.

To honor the self is to be willing to know not only what we think but also what we feel, what we want, need, desire, suffer over, are frightened or angered by — and to accept our right to experience such feelings. The opposite of this attitude is denial, disowning, repression, self-repudiation.

To honor the self is to preserve an attitude of self-acceptance — which means to accept what we are, without self-oppression or self-castigation, without any pretense about the truth of our own being, pretense aimed at deceiving either ourselves or anyone else.

To honor the self is to live authentically, to speak and act from our innermost convictions and feelings.

To honor the self is to refuse to accept unearned guilt and to do our best to correct such guilt as we may have earned.

To honor the self is to be committed to our right to exist which proceeds from the knowledge that our life does not belong to others and that we are not here on earth to live up to someone else's expectations. To many people, this is a terrifying responsibility.

To honor the self is to be in love with our own life, in love with our possibilities for growth and for experiencing joy, in love with the process of discovery and exploring our distinctively human potentialities.

Thus we can begin to see that to honor the self is to practice selfishness in the highest, noblest, and least understood sense of that word. And this, I shall argue, requires enormous independence, courage and integrity.[5]

RD 18. I Let an Abuser Know that I Am a Victim

1. I send out signals to an abuser that I am a victim primarily through my communication patterns. I alert him that I fear power through my tendency to cry. I send out weakness signals by pointing out my shortcomings to him. I volunteer damaging information about

[5] From *Honoring the Self: the Psychology of Confidence and Respect,* by Nathaniel Branden, Bantam. Reprinted by permission.

myself. Because I feel helpless, I feel it is alright to rely on him. My demands, however, are more than he can, or will, fulfill.

2. From my childhood, I coped by adopting a martyr stance for relating to others. It is often difficult for me to utilize assertive strategies in my adult interpersonal relationships with men. My communication has repeated patterns of trying to appease or second guess him. Mind reading is an art for me. I am often supersensitive to his needs. My speciality is trying to accommodate what he wants. I let him know that he is more powerful than I am.

3. Apologizing or saying, "I'm sorry," relates an impotent position to him: "I'm weak." "I'm not worth much." "Please don't hurt me." This communicates to him that I am not powerful and includes a plea for leniency. It is difficult for me to defend my rights or insist on limits. My boundaries and limits of tolerance are poorly communicated to him.

4. Repressing my own needs and feelings is an adaptive behavior pattern that I carry over from my childhood. Saying "no" is almost an impossibility because I desire approval and find it difficult to offend him. It is hard to acknowledge my personal needs because I learned to regard them as an imposition. I have a difficult time making decisions. I fear making the wrong decisions and paying the consequences. I do not feel that I have a rightful heritage to a satisfying life. My behavior is one of learned helplessness and a position that suffering is a way of life.

5. When I sense that I am the center of critical attention from my partner, I am easily wounded. I fear criticism because my self-esteem depends solely on his estimation of me. I am very self-involved, constantly checking my progress or success by seeing myself in his eyes. I am thrown off-center by what he thinks of me. I give him the power to affect my view of myself. If he is happy with me, I am happy with myself; if he is not, I am not. I am an approval addict who spends so much time evaluating my behavior that when I am criticized by him, it is almost too much to bear.

6. I am terrified by his hostility and do not believe that I should ever get angry. I have a great tolerance for emotional pain. I can put up with a lot of inexcusable behavior from the man in my life. I can be suffocatingly sweet. To feel safe with my partner, I am compliant and become what I believe he wants me to be. My self-esteem rests on being affirmed by him. I have an imaginary, idealized self, a perfect self. I find myself angry and resentful for not being perfect. I have a difficult time accepting myself as ordinary, or mediocre. I am critical of myself and others. Treating myself with care and a sense of self-preservation is not something that comes naturally to me within a relationship. I find myself attempting to drive painful anxiety about my relationship underground with self-destructive addictions: alcoholism, drugs, shopping sprees, overeating, or compulsive cleaning.

7. I guard vigilantly against expressing my anger and pay particular attention to the expression on his face and the tone of his voice. I either turn my anger inward and get depressed. Or I express it inappropriately in a hostile and explosive manner. I can't tolerate uncertainty. It makes me feel very uncomfortable; I have a strong urge to make everything alright. Sometimes when I try to correct things I make them worse.

RD 19. Virginia

Virginia had an adventurous life before she became involved with Bob. In the sixties she left Seattle to work in the Civil Rights struggle in the South. Later, her company transferred her from Seattle to Anchorage. In those days, before the pipe line boom, there were few black people there, which perhaps exacerbated the loneliness she had felt. Nevertheless, she did have some friends, and it was through them that she met Bob, who was gentle, kind and romantic.

After they were married he continued to display those traits at times, while at others he was morose and uncommunicative. His was a "Jekyll-and-Hyde" pattern common to many abusive men.

Virginia was twenty-five when she married this thirty-five-year-old father of four boys. Immediately after the marriage, she became an instant mother to three of his children and maid to the household of males. Although she felt used and demeaned by Bob from the start, the physical violence didn't begin until they had been married several years and the boys had returned to their mother.

It took Virginia three years to regain the confidence she had lost during the first five years of her relationship with Bob, and to gather the courage once again to strike out on her own. She has now been divorced for three years and is a student, with plans to be a counselor or teacher.[6]

RD 20. Your Inner Child

Whether we like it or not, we are simultaneously the child we once were, who lives in the emotional atmosphere of the past and often interferes in the present, and an adult who tries to forget the past and live wholly in the present. The child you once were can balk or frustrate your adult satisfactions, embarrass and harass you, make you sick — or enrich your life.[7]

RD 21. Effects of Domestic Violence on Children

Children are present in 41-55 percent of homes where police intervene in domestic violence calls.

Lenore Walker's 1984 study found that mothers who were battered were 8 times more likely to hurt their children.

In a major study of more than 900 children at shelters, it was determined that 70 percent of the children were victims of physical abuse or neglect. Almost 50 percent of these children had been physically or sexually abused. This study also found that the male batterer most often abused the children.

Children in homes where abuse occurs may indirectly receive injuries. They may be hurt when items are thrown or weapons are used. Babies may be hurt if they are being held by their mother when the batterer strikes out.

Boys who witnessed domestic violence as children are more likely to batter their female partners as adults than boys raised in nonviolent homes.

[6] From *The Ones Who Got Away: Women Who Left Abusive Partners,* by Ginny NiCarthy. Seal Press. Reprinted by permission.

[7] From *Your Inner Child of the Past,* copyright © 1963 by W. Hugh Missildine. Copyright renewed by Alice Keil. Reprinted by permission of Simon & Schuster, Inc.

RD 22. Leaving Plans

Many battered women leave their partners three or more times. It can take a long time to break emotional bonds. Going back doesn't mean I've failed. It just means I wasn't ready to leave yet.

The following behaviors should warn me that a "safety plan" needs to be developed:

- My partner uses alcohol or drugs in a state of rage and depression
- My partner has extreme rage about me leaving him
- My partner hunts me down and harasses me
- My partner threatens that the violence will escalate
- My partner uses such statements as, "I can't live without you;" "I'm going to end it all;" "I'll kill you if you leave me."
- My partner has a past history of homicide or suicidal behavior.

The benefits or reasons to leave:

- Safety from mental and physical abuse for myself or my children
- Increased feelings of control over my life
- An increased sense of independence
- More self-respect, self-confidence, and a sense of identity
- Increased peace of mind

I should ask the following questions of myself as I develop a safety plan:

- Am I knowledgeable about the shelter, legal, and welfare options in my community?
- Do I have reliable transportation?
- Do I have the number to a hotline for abused women?
- Do I know about restraining orders?
- Do I have a friend that I can safely call if things get really bad? Can I identify myself to my friend? Is there some sort of code that the two of us could devise?
- Can I predict what will happen to me if I do leave? What should I anticipate and plan for now?
- Does he know the whereabouts of all my friends or relatives? Whose home might be considered for a safe refuge?
- Whose whereabouts does he know? Would they set up a communication linkage with me in the event that he looks for me there?
- What can I do so that I'm not found?
- In the event that I need to go to another state, do I have national shelter phone numbers?

- In the event that I need to leave hurriedly, do I have an extra set of keys for the house or car?

- Do I have access to money? Credit cards? Do I have blank checks?

- Do I have quick access to all important documents like birth certificates, social security cards, car registration, etc.?

- Do I have all the things I want to take with me in one place? Do I have a friend who could keep a suitcase of important items?

- Do I know what toy or blanket will make my child feel secure?

RD 23. Depression

Symptoms of Depression

- Feelings of despair, sadness, hopelessness

- Difficulty sleeping, early wakening, difficulty getting out of bed

- Thoughts of "ending it all," "why bother?"

- Restlessness, irritability, guilt

- Low self-esteem or self-criticism

- Eating disturbance; usually loss of appetite or weight gain

- Fatigue, decreased energy, low motivation

- Memory loss; concentration diminished

- Loss of interest and pleasure in activities once enjoyed

Common Causes of Depression

We are apt to feel depressed when we:

- Are physically fatigued, ill, or run down

- Have lost a dream or a goal

- Feel guilty about something we have done, or haven't done

- Have been hurt by someone, have lost someone we love, have gone from a situation where we were happy to one that seems to hold no hope

- Feel lonely or inferior

POWER THOUGHTS

PT A. Our Purpose

We come together to take action against abusive relationship patterns. Our purpose is to mutually benefit abused women who need to feel a sense of belonging after feeling humiliated, isolated, helpless, and emotionally exhausted because of abusive relationships.

We admit that we need the support of other women who have experienced abuse.

We want peace of mind, hope, and help for a better way of life. Our future is based on our resolve to change our own attitudes and behaviors.

We take this time to look at our participation in abusive relationships. We have a willingness to look at ourselves in the abusive situations of our lives. It is essential to admit that we have experienced pain in our love relationships. Through confidential interaction, our purpose is to gain support and hope in our new lives. Our source of strength is our truthful stance of expressing the facts about our involvement in abusive relationships.

This support group is a learning opportunity to exchange information and explore positive life options for our individual sense of serenity and wholeness as we move toward positive lifestyles.

PT B. Inner Guides

As women who have experienced abuse, we must look to our feelings as beneficial guides in helping us understand the effect abuse has had upon our lives. Feelings can help us to identify who and what is good for our lives. Let this be an opportunity for us to make friends with our feelings. We must realize that feelings hurt most when they are denied. Feelings are emotional responses to events that happen in our daily lives. Feelings get expressed through our bodies: a knot in our intestines can tell us that we are anxious; sweaty palms can tell us that fear is being experienced; voice patterns that seem faster can signal internal confusion; tears in our eyes may indicate sadness, anger, or pain. Even when we are not consciously aware of it, our body is giving off helpful clues that we have feelings. Feelings are inner road maps; they are communication and signals. Feelings guide us toward self-preservation. Recognizing feelings is the key for abused women who want a positive life. The honest exploration of our inner feelings can get us ready to start asking ourselves the essential question: "What is best for me?"

PT C. Desiderata[1]

You are a child of the universe, no less than the trees and the stars; you have a right to be here.

And whether or not it is clear to you, no doubt the universe is unfolding as it should.

Therefore, be at peace with God, whatever you conceive Him to be, and whatever your labors and aspirations, in the noisy confusion of life keep peace with your soul.

With all its sham, drudgery and broken dreams, it is still a beautiful world.

Be careful. Strive to be happy.

[1] Found in Old Saint Paul's Church, Baltimore: dated 1692.

PT D. One Life[2]

There are countless paths of knowledge
There are many ways to give
There are endless hopes to dream of
There is only one life for us to live

Don't waste your time in sorrow
jealousy or pain
pity, envy, depression
or things that are the same

Every year that we get older
more often you hear people say
I wished I would have, I should have done
I just wasted another day.

PT E. When You Feel Down[3]

When you feel down over a situation that you would like to see changed, *focus on your control.*
Even in those situations where your direct control is negligible, you can still choose to respond
in ways that lessen your frustration, upset, and depressed feelings. Where you have a substantial
degree of control in changing the circumstances that are contributing to your negative feelings,
focus on your responsibility to yourself to do what you can to be happier. Where the control issues
are unclear, remember that developing your alternatives and choosing to take some action has
a value independent of whether or not the actions you take completely remedy the problematic
situation. That value is to lessen your sense of helplessness.

Accepting your depressed mood, then, means also that you take a hard honest look at the
situations from which your low moods arise and decide where you can productively exercise
choice and control. Accepting what you can't change may sometimes imply that you must accept
and experience sad feelings.

PT F. We Must be Strong, by Walter Rinder[4]

It is not enough that God gives us gifts of love,
gifts of physical beauty, gifts of talent; for these are
only a few of the pillars which are rooted in the
foundation of our personality. The strength of this
foundation is life. The building starts at birth. Its
strength over the years, our mending the cracks
replacing the parts that crumble or are weakened

[2] From *This Time Called Life.* Copyright © 1971 by Walter Rinder. Reprinted by permission of Celestial Arts, P.O. Box 7123, Berkeley, CA 94707.

[3] From *Getting Up When You're Feeling Down: A Woman's Guide to Overcoming and Preventing Depression,* by Harriet Braiker. G. P. Putnam's Sons. Reprinted by permission.

[4] From *You Can Be Free*, Celestial Arts. Reprinted by permission.

by time; depend on our perception, our confidence, our giving and receiving, our interacting with life, our sensitivity, fulfilling our commitments and honoring our word. Also the strength of this foundation depends on our understanding and overcoming hurts and pains, disappointments and failures, conditioning and fears. For these are the storms which can destroy (lay these pillars to ruins) or weaken our mind and our body.

From birth until death these storms are constantly tearing down people who can't build the strength to stand against their might. Cities are full of these people and cities are the eyes of these storms.

So many human beings lie in the rubble of their personality.

PT G. Are You Somebody Besides Wife, Mother, or Girlfriend?

Many women can't tell where the family leaves off and they begin. They feel they're just a part of their children or their husbands. They forget that they have a separate identity.

Try to answer these questions:

1. What do I want?

2. What do I want to do now?

3. What do I like to do?

4. Whom do I like to spend time with?

5. What do I like to wear?

6. Where do I like to go?

7. Where would I like to live?

8. What do I want to be doing in five years?

9. What do I want to be doing in ten years? Twenty years?

How many of your answers were something like this?

"I want to live here because moving would mean changing the kids' schools."

"He likes me to wear"

"I don't much care — I'm easy to please."

"My husband wouldn't hear of it."

"It costs too much."

If your answers were like that, they don't say what you want. They are about what other people want. Or they say what you think can't happen, rather than what you want.

Try answering again. This time, don't think about how other family members would be affected. This doesn't mean you don't care about them. It simply means that you deserve some things you want. It means that you count for something. You are a person, too.

PT H. Sharing Our Experience

As women who have known abuse we need to hear the statements of other women who share this same experience. Nothing that is said within this support group is empty of meaning for our lives. We can develop positive lives. The greatest contribution we can make to the lives of other women is to be affirming. As abused women we can make a difference in this world through our sharing of our painful backgrounds. We can create new attitudes towards the lessons life has offered. Women within this group are special to our growth. Our paths have crossed for a reason. Our goals are the same: As one sister is healed, we are all healed.

PT I. Our Children

Our children are our gifts. Children look to us for direction. Their hearts are so open to the events in their lives. What they react to spontaneously is what they feel, is who they are. We must have close observation of our children. We must see how complex their lives have become because of the abuse. We must be determined to offer them a life without fear and scenes of domestic violence. Let us have a firm resolve to create lives for our children so they are not emotionally scarred when they reach adulthood.

PT J. My Declaration of Self-Esteem

I am me. In all the world there is no one else exactly like me. There are persons who have some parts like me, but no one adds up exactly like me. Therefore, everything that comes out of me is authentically mine because I alone chose it.[5]

PT K. We Must Remember

We must remember that peace is the reward we seek. Let us have the courage to honestly look at our lives and loosen the ropes that have tied us to abuse. Our search for peace must be unending. This time our fears must not overwhelm us. We must display courage to the challenges that will meet us. There is meaning in our coming together. We must let ourselves be touched by another woman's words. No problem is too great to be faced alone any longer. Secrets keep us isolated. Let us have the courage to say to ourselves: "I will listen and share and be well".

[5] *My Declaration of Self-Esteem.* Copyright © 1970 by Virginia Satir. Reprinted by permission of Celestial Arts, P.O. Box 7123, Berkeley, CA 94707.

PT L. What We Call Life, by Walter Rinder[6]

We arrive in this world alone . . . this time called
life was meant to share.

Under the cover of the stars,
under the cover of the sun fermented into eternity
there lies a precious moment of time we call life.
A gift of Creation.
We are given minds to discover,
talent to create,
curiosity to gain knowledge,
insight to build,
emotions to communicate our feelings,
and movement through our physical body.

 Open your gift!

[6] From *This Time Called Life*. Copyright © 1971 by Walter Rinder. Reprinted by permission of Celestial Arts, P.O. Box 7123, Berkeley, CA 94707.

VISUALIZATIONS

Visualization A.

Take a deep cleansing breath (pause). — Close your eyes, taking in deep breaths — breathe in positive thoughts of confidence, hope, and serenity — breathe out any sadness, hopelessness or grieving. — Your eyes feel very heavy. You are so relaxed and peaceful (long pause). In your mind I want you to visualize that you are sitting by a stream — the water in this river is calm and looks like a big sheet of glass. Remember to breathe. This river instantly becomes a window — you cup your adult hands around your eyes to look inside this special window — in an instant you can see everything so clearly — there's a little girl and she's beckoning you to come near her (pause). Her voice sounds so familiar: "It's me, I'm the little girl you were in childhood. — Come with me and take my hand. Don't be afraid." — Your body feels calm and relaxed. — This little girl's hand holds yours as you are led back to the scenes of childhood (long pause). You take in a long breath and hold it deeply (pause). You exhale fear and any feeling of being nervous — you see the sun shining through the leaves, just like it did when you were a little girl (pause). You hear the birds noisily talking to each other — you feel a sense of confidence about yourself — you feel that something special is about to happen — your eyes see a special door opening and people from yesterday are coming toward you with hugs of appreciation, and love in their eyes. You feel so capable and loved (long pause). The hugs are the best ones you've ever had — your whole body is filled with joy — the last person to give you a hug is a patient little girl who looks

like you when you were young (pause). — This little girl asks, "Will you me hold me real tight?" And as you do, she whispers something in your ear: "I really love you. You are so special. No one is quite like you. Believe in yourself, you are worthy of love. What you have to say is valuable. Your feelings and opinions are valuable — you will walk with yourself for a lifetime. — Please promise to not let go of yourself. — See yourself completing your goals successfully — let me give you a hug that will be with you always." (pause). You have a strong inner knowing confidence (pause). This little girl takes your hand and leads you back through the open window — she smiles just like you did in an elementary school picture and says: "Get going you, you are so special. So don't forget it this time. Walk into the future days as if you are loved. Good-bye me." (Pause). Take in long deep breaths (long pause). Prepare your mind to come back to this room — listen to my voice.

Breathe and on the count of three open your eyes. — One. — Two. — Three.

Open your eyes. (pause). You feel confident and worthy to have a life of happiness.

Visualization B.

Close your eyes and let go of anything that might be bothering you. Take deep breaths (pause) — as you breathe, remember to feel relaxed (pause). After each relaxing breath, composure and serenity flow into each cell in your body (pause) — relax and take deep breaths that release all worry and anxiety — your mind is relaxed and sends a feeling of serenity down to your neck, shoulders, arms, (pause) your chest, — your stomach.

All anxiety is let go (pause). Your upper legs, knees, and feet are relaxed (long pause). A warm relaxing current of energy is flowing throughout your whole body . . . you see yourself walking — walking in a beautiful green forest (pause). Before your eyes is a majestic tree — it is early dawn and the tree is enshrined in a foggy mist — the sky is a pastel gray (pause). You feel so relaxed and serene — in your mind's eye you see a deer gracefully climbing the mountain — the air is slightly cool — there is nothing that you have to problem-solve or fix — you are calm (pause). As you look at the tree, your mind is very strong and powerful — you feel a knowing sense of being in control — harmony flows to every cell in your body (pause). The warm white sun slowly rises behind the tree — the air seems warmer — you are relaxed and confident (long pause). The sky becomes blue — you hear birds singing — this is your private sanctuary of peace and tranquillity (pause). Remember your breathing — breathe in and out (pause). Prepare your mind to vividly remember this majestic tree and your private sanctuary — breathe in and out — ready your mind to come back to the group (pause) you are totally refreshed and feel confident (pause).

On the count of three you are alert — One — Two — Three — Open your eyes.

Visualization C.

Close your eyes and take a deep cleansing breath (pause). Hold it and have a firm resolve to exhale any negative thoughts that might be harbored in your mind (pause). Breathe in — and breathe out all fear, anxiety, and depression (pause). Your eyes are

very heavy. Feel yourself take a deep breath that fills your body with a sense of lightness (pause). Feel relaxation within you. — Now imagine yourself floating upward in a beautiful bubble — as you go higher and higher you are filled with a wonderful feeling that all will work out — this feeling of joy is in every cell in your being (pause). It's a day where the sky is blue and the sun sends warm rays that touch your whole body (pause). You feel happy and all fears seem so insignificant — the cars and trees below are so small and insignificant — you are breathing special air. . . Happiness is pulsing through your body . . . you feel wonderful. — Take a breath of this special air (pause), breathe out any negative fears. In your mind, prepare to come back to this room — imagine the bubble slowly floating downward (pause). You feel the warm sun and see the blue sky — you feel centered and have a positive mind — the cars and trees are larger now (pause) breathe in and out (pause). You are coming back to your life and can cope with all of its problems — all of your senses are becoming more and more alert. Prepare yourself to come back to this room — on the count of three. — One. — Two. — Three (pause). Open your eyes.

Visualization D.

Close your eyes and try to relax every muscle in your entire body (pause). Take in deep cleansing breaths that help you become peaceful — exhale any tensions of being tired. Let go of fatigue or any feelings of inner sadness that you now might be feeling (long pause). Feel your eyelids become heavy and very tired (pause). You gave your best to this day. Let go of any inner statements that you could have done better . . . relax your

neck and shoulders, and adjust your body so that you feel completely comfortable (pause). Feelings of serenity and peace float through your mind — you feel secure — you feel that you have control over the next chapter in your life (pause). Now in your mind imagine that you are creating a sanctuary that surrounds you. — This beautiful sanctuary has beautiful walls that are made of redwood. The windows are made of stained glass and crystal — This special sanctuary is your protection against the world (long pause). — It has thick walls that are strong — it cannot fail you (pause). Negative energy is kept out of this sanctuary, and only positive, loving energy can pass through its walls (pause). Imagine that this sanctuary fills you with personal power and self-love — you feel self-worth. — See yourself confident and powerful — take this moment to see yourself enthusiastic (pause). — In an instant the walls of sanctuary are gone — you need their protection no more — you have an inner friendship with yourself — you realize that you must respect yourself first before anyone else does — you know that you can never lose yourself, nor leave yourself. — You are the solution to your life and all its problems (pause). You realize that you are the one at the helm of life. Breathe in and out — take in deep breaths. — You deserve this time to feel a sense of control (long pause). In your mind, firmly remember the sanctuary's walls and its beautiful windows of stained glass. — Feel secure that at any time you can feel that you are within the sanctuary and its walls — no one can make you feel worthless anymore. — Prepare your mind to come back to your support group — feel confident. — Breathe — breathe in self-worth. — In all the world no one is as special as you are — carry that feeling

as you become more and more alert. — When you are ready, gradually open your eyes. You are fully alert and at peace with yourself.

Visualization E.

Close your eyes and remember to breathe in and out. (long pause) Let oxygen flow into your lungs. Relax and let calmness flow into every cell of your body —Your mind is cleared of all of its worries — you feel centered (pause). Imagine that you are with the women in your support group — you are all sitting in a circle in a beautiful meadow (pause). — The sky is blue and you hear the sounds of nature all around you (pause). All around you are beautiful little yellow flowers, seagulls fly as the warm sun flows down on everyone (pause). You feel surrounded by women who are friends — women you can feel bonds with — women who can share your real thoughts and feelings (pause). This meadow continues to make you feel relaxed and calm. — In your mind you feel such a closeness to these women. — This group of women make you feel that wonderful — you are so special — comfort flows into every cell of your body (pause). — You are aware of feeling very strong through the friendship of these women — a warm comforting energy field of white light is around you and this group of women. You feel a sense of being connected with these women (pause). Remember these wonderful feelings — look at the warm sun, hear the sounds of the birds and remember this special support group. Breathe in and out — let your body slowly become more alert. — When you want to, open your eyes and see the women in your support group.

Visualization F.

Close your eyes and take in a deep breath. — Hold this breath and as you breathe out, let go of the tension and confusion in your mind. — Remember to breathe in and out. — Let your whole body totally relax. Quiet your mind of its worries and fears (pause). Take in a breath and let it fill your lungs with oxygen (pause). Exhale any stress or tension that may be harbored in your body (pause). Roll your neck to the right (pause). Roll your neck to the left (pause). Slowly breathe in and out and gently let your mind become more and more relaxed (pause). Let your mind go away to the sea (pause). You hear the sounds of the ocean (pause). Above you is the orange sun and you feel its positive light filling your brain with positive feelings (pause). — Its warm light flows down through your whole body. Your neck — shoulders — into every cell and atom of your body (pause). You feel comfortable and relaxed (pause). — You enter a special journey of inner peace — you feel happiness (long pause). Soft white cottony clouds are above you in the sky — you sense yourself with warm feelings of confidence and self-love (long pause). — Your mind is imprinted with this experience (long pause). — Look at the clouds as they drift from each other. Feel the warm sun on your whole body (pause). As your mind comes back to this room, it is free of worry. — Remember to breathe slowly (pause). Now bring yourself back to this present time (pause). — You are relaxed and peaceful (pause). When you are ready, open your eyes and come back to this group.

HANDOUTS

These Handouts may be copied as needed.

H 1. What Is Abuse?

"Abuse" will be used in this definition to indicate violence inflicted upon a woman by a man with whom she is married or cohabiting. Abuse can be found among married and unmarried heterosexuals, lesbians and gays. It cuts across geographic, religious, economic, and racial barriers. Abuse is a pattern of control that a man exercises that physically harms, induces fear, prevents a woman from doing what she wishes, or forces her to perform in ways she does not want to. Abuse includes physical, sexual or emotional attacks.

Physical abuse is: A) pushing, scratching slapping, hitting, punching, choking, kicking, holding, biting, or throwing; B) locking you out of the house, driving recklessly when you are in the car, throwing objects at you, threatening to hurt you with a weapon, abandoning you in dangerous places, refusing to help when you are pregnant, injured, or sick.

Emotional abuse is: ignoring your feelings, ridiculing your beliefs, withholding approval, threatening to take your children, telling you about his affairs, manipulating you with lies, threatening to leave you, taking the car keys or money, keeping you from working or going to school, humiliating you in public or private, abusing your pets or children, calling you names, or driving your family or friends away.

Sexual abuse is: insisting that you dress in an uncomfortable sexual way, calling you sexual names like "whore," "bitch," forcing you to strip, forcing unwanted sexual acts, withholding sex, criticizing you sexually, insisting on unwanted touching, assuming you would have sex with any available man.

H 2. Characteristics of Battered Women and Their Batterers

Battered Women

1. Low self-esteem.

2. Believes all myths about battering relationships.

3. Is a traditionalist in the home, strongly believing in family unity and the prescribed feminine sex role stereotype.

4. Accepts responsibility for the batterer's actions.

5. Suffers from guilt yet denies the terror and anger she feels.

6. Presents a passive face to the world but has strength to manipulate her environment so she does not get killed.

7. Has severe stress reactions with psychophysicological complaints.

8. Uses sex as a way to establish intimacy.

9. Treated as "Daddy's Little Girl" as a child.

10. Believes no one will be able to help her resolve her predicament except herself.

Batterers

1. Low self-esteem.

2. Believes all myths about battering relationships.

3. Is a traditionalist in his home, believing in male supremacy and the stereotypic masculine sex role in the family.

4. Blames others for his actions.

5. Is pathologically jealous and intrusive into his woman's life.

6. Presents a dual personality . . . Dr. Jekyll and Mr. Hyde.

7. Has severe stress reactions during which he uses drinking and wife-beating to cope.

8. Uses sex as an act of aggression frequently to overcome impotence or bisexuality.

9. Suffered from child abuse or neglect as a child.

10. Does not believe his violent behavior should have negative consequences.

H 3. National Statistics on Domestic Violence

- In 1985, over 1,300 women were killed by a husband or boyfriend, which was 30% of the total homicides of females; 6% of the male victims of homicide were killed by their wives or girlfriends. (Federal Bureau of Investigation. (1986). *Uniform Crime Reports: Crime in the United States*. 1985. Washington, DC: U.S. Department of Justice)

- Approximately 37% of pregnant patients, across class, race, and educational lines, are physically abused. (Helton A, McFarlane J, Anderson E. Battered and pregnant: a prevalence study. *Am J Public Health*. 1987: 77: 1337-1339)

- Four million women are severely assaulted per year. (Langan Pa, Innes CA. *Preventing Domestic Violence against Women*. Washington, DC: US Department of Justice, Bureau of Justice Statistics: 1986)

- Over one-third of assaults to women involve severe aggression such as punching, kicking, choking, beating up, or using a knife or a gun. (Langan Pa, Innes CA. *Preventing Domestic Violence against Women*. Washington, DC: US Department of Justice, Bureau of Justice Statistics: 1986)

- From one-fifth to one-third of all women will be physically assaulted by a partner in their lifetime. (Frieze I H, Browne a. Violence in marriage. In: Ohlin L, Tonry M, eds. *Family violence: Crime and Justice*, a Review of Research. Chicago, Ill: University of Chicago Press; 1989: 163–218)

- The rate of injury to women from battering surpasses that of car accidents and muggings combined. (McClear SV, Anwar RA. The role of the emergency physician in the prevention of domestic violence. *Ann. Emerg. Med.* 1987: 16: 1155-1161)

- Approximately 95% of the victims of battering are women. (Bureau of Justice Statistics, Report to the Nation on Crime and Justice: The Data, Washington, DC: Office of Justice Programs, US Department of Justice, October 1983)

- Twenty-one percent of all women who use the hospital emergency surgical service are battered. (Stark, E. *Wife abuse in the medical setting: an introduction for health personnel.* (Monograph ser. No. 7) Rockville, MD, National Clearinghouse on Domestic Violence, April 1981)

H 4. Feeling Guides

Note to facilitator: Prompt participants or client to say "I feel," before reading out loud the group of feelings (1 through 8). The whole group of feelings can be read by eight designated women. Inquire if any of these feelings can be identified as a present "feeling" experience.

Start each word with *I Feel:*

[1]
Lonely
Depressed
Lost
Empty
Discouraged
Rejected
Disappointed
Hurt
Crushed
Drained
Vulnerable
Used
Confused
Bored
Shy
Abused
Down
Sad

[2]
Happy
Amused
Delighted
Pleased
Cheerful
Grateful
Surprised
Relieved
Hopeful
Enthusiastic
Elated
Glad
Excited
Turned On

[3]
Caring
Loving
Sympathy
Pity

[4]
Competent
Confident
Determined
Proud
Fulfilled
Capable
Needed
Secure
Important
Appreciated

[5]
Blocked
Trapped
Burdened
Smothered
Overwhelmed
Frustrated
Torn
Driven
Exasperated

[6]
Panicky
Frightened
Anxious
Threatened
Scared
Worried
Afraid

[7]
Embarrassed
Ashamed
Humiliated
Helpless
Ignored
Neglected
Doubtful
Unimportant
Regretful
Unsure
Intimidated
Uncertain
Left Out
Unappreciated
Insecure

[8]
Mad
Angry
Hostile
Furious
Hateful
Bitter
Irritated
Resentful
Jealous
Envious
Disgusted
Cheated
Agitated
Upset
Offended
Slighted

90

H 5. Positive Phraseology For Our Children

How we incorporate our words in sentences is one of the main ingredients in fulfilling or unfulfilling relationships with our children. The following are phrases which foster positive parenting. You might consider incorporating them into your communication patterns.

- "I feel deeply about this issue."

- "Your point of view is something I want to hear."

- "I want to solve this together."

- "Let's both have a little time to think about this problem."

- "I respect your reasons."

- "Educate me about what you know about this."

- "May I share how I feel with you?"

- "Tell me what you would do if you were in my shoes?"

- "What are some of your options?"

- "I need to study your information."

- "Your behavior is having an impact on me. I feel (uneasy, angry, anxious)."

- "Can you help me understand why this is important to you?"

- "I'm listening to your words."

- "Our relationship is something I care about."

- "I want to respect your feelings."

- "How do you feel right now?"

H 6. Effects of Domestic Violence on Children

Children are present in 41–55 percent of homes where police intervene in domestic violence calls.

Lenore Walker's 1984 study found that mothers who were battered were 8 times more likely to hurt their children.

In a major study of more than 900 children at shelters, it was determined that 70 percent of the children were victims of physical abuse or neglect. Almost 50 percent of these children had been physically or sexually abused. This study also found that the male batterer most often abused the children.

Children in homes where abuse occurs may "indirectly" receive injuries. They may be hurt when items are thrown or weapons are used. Babies may be hurt if they are being held by their mother when the batterer strikes out.

Boys who witnessed domestic violence as children are more likely to batter their female partners as adults than boys raised in benevolent homes.

H 7. Leaving Plans

Many battered women leave their partners three or more times. It can take a long time to break emotional bonds. Going back doesn't mean I've failed. It just means I wasn't ready to leave yet.

The following behaviors should warn me that a "safety plan" needs to be developed:

- My partner uses alcohol or drugs in a state of rage and depression
- My partner has extreme rage about me leaving him
- My partner hunts me down and harasses me
- My partner threatens that the violence will escalate
- My partner uses such statements as, "I can't live without you;" "I'm going to end it all;" "I'll kill you if you leave me."
- My partner has a past history of homicide or suicidal behavior.

The benefits or reasons to leave:

- Safety from mental and physical abuse for myself or my children
- Increased feelings of control over my life
- An increased sense of independence
- More self-respect, self-confidence, and a sense of identity
- Increased peace of mind

I should ask the following questions of myself as I develop a safety plan:

- Am I knowledgeable about the shelter, legal, and welfare options in my community?
- Do I have reliable transportation?
- Do I have the number to a hotline for abused women?
- Do I know about restraining orders?
- Do I have a friend that I can "safely" call if things get really bad? Can I identify myself to my friend? Is there some sort of code that the two of us could devise?
- Can I predict what will happen to me if I do leave? What should I anticipate and plan for now?
- Does he know the whereabouts of all my friends or relatives? Whose home might be considered for a safe refuge?
- Whose whereabouts does he know? Would they set up a communication linkage with me in the event that he looks for me there?
- What can I do so that I'm not found?

- In the event that I need to go to another state, do I have national shelter phone numbers?

- In the event that I need to leave hurriedly, do I have an extra set of keys for the house or car?

- Do I have access to money? Credit cards? Do I have blank checks?

- Do I have quick access to all important documents, like birth certificates, social security cards, care registration, etc.?

- Do I have all the things I want to take with me in one place? Do I have a friend who could keep a suitcase of important items?

- Do I know what toy or blanket will make by child feel secure?

H 8. Take Care of Your Physical Self[1]

It's important to take good care of your body. If you don't feel well, it can make you feel depressed. It can also make it hard for you to think clearly. Everything you do is affected by your body.

Eat well. Stay away from junk food. If you must have something sweet, buy or fix something really special. Let yourself plan it and enjoy it without feeling guilty. Otherwise, eat what's good for you and take the time to enjoy it. Don't eat on the run and don't skip meals.

Sleep well. Try to get about eight hours of sleep each night. If you have trouble sleeping, try to start relaxing an hour before bedtime. If it doesn't work, don't toss and turn. Pass the time enjoyably. Listen to soothing music. Read something light. Stretch and rest without trying to sleep.

Don't panic if you're not getting a regular good night's sleep. You won't fall apart. Don't tell yourself, "I've got to sleep tonight or I'll fall apart." That will make it even harder to relax and sleep.

If you feel tired most of the time, see a doctor. If you get sleeping pills, don't use them more than a month. A doctor might not tell you whether or not the pills are addictive. They can also have dangerous side effects. Drinking alcohol to fall asleep can be a dangerous habit, too.

Exercise. Exercise will make you feel and look better. Concentrate on the pleasure of moving your body. If you're out of shape, start slowly. Stay with it only as long as it feels good. If you stop while you're enjoying it, you'll probably do it again. Follow this principle whether you run, swim, do sit-ups, or join a team. It will help you to make exercise a regular part of your life.

Look well. The way you look affects the way you feel. Don't give yourself a chance to feel sloppy. Fix your hair. Put on whatever make-up you usually wear. Do these things even if you're not leaving the house or seeing anyone. It's a way of reminding yourself that you care about you.

[1] From *You Can Be Free: An Easy-to-Read Handbook for Abused Women,* by Ginny NiCarthy and Sue Davidson. Seal Press. Reprinted by permission.

H 9. Depression

Symptoms of Depression

- Feelings of despair, sadness, hopelessness
- Difficulty sleeping, early wakening, difficulty getting out of bed
- Thoughts of "ending it all," "why bother?"
- Restlessness, irritability, guilt
- Low self-esteem or self-criticism
- Eating disturbance; usually loss of appetite or weight gain
- Fatigue, decreased energy, low motivation
- Memory loss; concentration diminished
- Loss of interest and pleasure in activities once enjoyed

Common Causes of Depression

We are apt to feel depressed when we:

- Are physically fatigued, ill, or run down
- Have lost a dream or a goal
- Feel guilty about something we have done, or haven't done
- Have been hurt by someone, have lost someone we love, have gone from a situation where we were happy to one that seems to hold no hope
- Feel lonely or inferior

H 10. Holmes-Rahe Stress Test

In the past twelve months, which of these have happened to you?

Event	Value	Score
Death of a spouse	100	_____
Divorce	73	_____
Marital separation	65	_____
Jail term	63	_____
Death of a close family member	63	_____
Personal injury or illness	53	_____
Marriage	47	_____
Fired from work	47	_____
Marital reconciliation	45	_____
Retirement	45	_____
Change in family members	44	_____
Pregnancy	40	_____
Sex difficulties	39	_____
Addition to family	39	_____
Business readjustment	39	_____
Change in financial status	38	_____
Death of a close friend	37	_____
Change in number of marital arguments	35	_____
Mortgage or loan over $10,000	31	_____
Foreclosure of mortgage or loan	30	_____
Change in work responsibilities	29	_____
Son or daughter leaving home	29	_____
Trouble with in-laws	29	_____
Outstanding personal achievement	28	_____

Event	Value	Score
Spouse begins or starts work	26	_____
Starting or finishing school	26	_____
Change in living conditions	25	_____
Revision of personal habits	24	_____
Trouble with boss	23	_____
Change in work hours, conditions	20	_____
Change in residence	20	_____
Change in schools	20	_____
Change in recreational habits	19	_____
Change in church activities	19	_____
Change in social activities	18	_____
Mortgage or loan under $10,000	18	_____
Change in sleeping habits	16	_____
Change in number of family gatherings	15	_____
Change in eating habits	15	_____
Vacation	13	_____
Christmas season	12	_____
Minor violation of the law	11	_____

Total

The more change points you have, the more likely you are to contract some sort of stress illness. Of those people with a score of over 300 for the past year, almost 80 percent get sick in the near future. With a score of 150-299, about 50 percent get sick in the near future. And, with a score of less than 150, only about 30 percent get sick in the near future.*

* From *The Survey of Recent Experiences* (SRE), by Thomas H. Holmes. Copyright © 1981 by Thomas H. Holmes. Reprinted by courtesy of the University of Washington Press.

SUPPLEMENTAL HANDOUTS

These Handouts may be copied as needed.

Welcome

Have you ever wondered how you could lead your life towards a positive future? Would you like healthy relationships that are not characterized by abuse and fear?

This support group is your invitation to open your mind to healthy relationships. You are welcome to be a part of this support group.

You may think that you are the only woman in the world who suffers from an abusive relationship. This support group provides the opportunity to be involved with other abused women who want healthy love relationships.

Any fear you may have about attending this support group is normal. Participate when you want to. This is a confidential support group. The purpose of this support group is to help you increase your knowledge of what a positive relationship is, enhance your self-esteem, and eliminate self-destructive behavior. This support group is your educational resource; it is packed with learning! Treat yourself to a support group that can give you new tools for success. In no other support group will you find so many helpful skills! The information that will be covered would be very difficult to gather on your own. This support group can help you acquire so much information and support. Come join the fun and friendship of other women who can be supportive to your positive progress.

I urge you to join this support group. Invest your time and energy in the most valuable person in the world. . .**You**!

Positively,

Support Group Leader

100

Questionnaire: *Have You Been Abused?*

The following questionnaire can help you identify whether you are an abused woman. Your courage and willingness to fill out the questionnaire indicates your willingness to want a positive life. Consider your present or past relationship. Even though you may not be in a relationship, you might still be recovering from an abusive relationship. Circle **Yes** or **No**.

1. **Yes** **No** Do you find yourself trying to drive painful fear anxiety underground with self-destructive addictions: alcoholism, shopping sprees, overeating, negative relationships, compulsive cleaning, drugs?

2. **Yes** **No** Has he locked you out of the house, taken the car keys or money, humiliated you in public, abused your pets or children, or driven your family or friends away?

3. **Yes** **No** Do you feel that you live in fear because he has pushed, scratched, slapped, hit, punched, choked, kicked, tightly held, bit, or thrown you in your relationship?

4. **Yes** **No** Are you terrified of his anger? Do you keep a vigilant guard to be perfect so he won't get angry?

5. **Yes** **No** Do you have a communication style with him of trying to appease or second-guess him?

6. **Yes** **No** Has he driven recklessly when you are in the car, thrown objects at you, threatened to hurt you with a weapon, abandoned you in dangerous places, refused to help when you are pregnant, injured, or sick?

7. **Yes** **No** Do you seem to have this martyr stance of: *"Even if you step on me, I will still love you. I am giving, loving, and forgiving?"*

8. **Yes** **No** Do you find it difficult to face reality in your relationship and often find yourself fantasizing about what it could be like?

9. **Yes** **No** Do you lie awake worrying about your abusive relationship?

10. **Yes** **No** Are you embarrassed to discuss your relationship situation with your friends or relatives?

11. **Yes** **No** Do you withdraw from friends, relatives and outside activities when your relationship is not working?

Count the number of "yes" responses that you gave and compare that number to the breakdown below. If you feel that you are currently involved in an abusive relationship, do not lose hope. There are many resources in your neighborhood that you can turn to for help.

1–2 You are probably affected by "love dependency" (a preoccupation with a relationship).

3–6 You are suffering from abuse and should start examining what is happening in the relationship.

7–9 You should seriously start examining your relationship more closely as you are showing signs of being involved in abuse. Abuse is definitely the issue.

10–11 Crisis intervention needed! Seek individual help from a counselor familiar with abuse. Joint therapy not appropriate!

RECOVERY GROWTH STEPS
(Based on RD 4)

These cards may be copied, and pasted on 3 x 5 cards.

1. I will let go of my personal denial which inhibits me from being truthful about abuse. I will closely examine how abuse has affected my life.

2. I will admit to at least one woman that my relationship has been painful. I will admit that I have been abused. I will admit that my brain has responded with some of the following: helplessness, depression, hopelessness, denial, guilt, indecision, resentment, and/or neglectful parenting.

3. I will admit that I have spent a lot of time badgering my abusive partner to break down his defenses so he can listen to me. To control a relationship, I have used mental or sexual manipulation, nagging, submission, or psychoanalyzing.

4. I will not dwell on my past mistakes. I can learn from my past involvement in domestic violence. I will let go of my inclination to criticize myself for the abuse. I will focus on myself. I will initiate and incorporate into my life a supportive network of people who are capable of giving healthy love.

5. I will not set myself up to suffer or be a martyr to a man who verbally or physically abuses me.

6. I will learn how to release others so they can live their own lives.

7. I will admit that it is okay for me to express anger. I will learn positive anger skills. I do not have to be quiet when I am angry. I do not have to submit to be verbally or mentally assassinated by an angry or stressed out mate.

8. I will stop procrastinating about what is important for my future and my happiness.

9. I will not involve myself in relationships that are abusive and do not encourage my well being.

10. I will take time to get to know the man I am considering for a close relationship. I will explore my friendship with a man, first, before we become involved in a relationship. I will not decide impulsively that he is "just what I have always wanted," and will wait to see if he can be a friend and keep trust agreements. I will examine whether I might get abused in a possible relationship.

11. When I am in a relationship, I will not try to devote all my time to making it work. My expectation is that a man will also put effort into the relationship.

12. I will strive to know what I want in life and will give myself happiness. I will develop my happiness from within and will not allow an abusive man to lead me away from my friends or relatives.

SUGGESTED READING

On Alcoholism

Allen, Chaney. *I'm Black and I'm Sober*, CompCare, Minneapolis, 1978.

Johnson, Vernon E., *I'll Quit Tomorrow*, Harper & Row, San Francisco, 1980.

Kirkpatrick, Jean Ph.D., *Goodbye, Hangover, Hello, Life*, Atheneum, New York, 1986.

Nellis, Muriel, *The Female Fix*, Houghton Mifflin, Boston, 1980.

Sandmaier, Marian, *The Invisible Alcoholics*, McGraw-Hill, New York, 1980.

Wegscheider, Sharon, *Another Chance: Hope and Health for the Alcoholic Family*, Science and Behavior Books, Palo Alto, 1981.

On Domestic Violence

Foat, Ginny, *Never Guilty, Never Free*, Random House, New York, 1985.

Loeb, David, & Brown, David, *How to Change Your Name in California*, Nolo Press, Berkeley, CA 1990.

Martin, Del, *Battered Wives*, Volcano Press, Volcano CA, 1981.

McNulty, Faith, *The Burning Bed*, Bantam, New York, 1981.

NiCarthy, Ginny, *Getting Free: A Handbook for Women in Abusive Relationships*, Seal Press, Seattle, 1984.

NiCarthy, Ginny; Merriam, Karen; & Coffman, Sandra, *Talking It Out: A Guide to Groups for Abused Women*, Seal Press, Seattle, 1984.

Saldana, Theresa, *Beyond Survival*, Bantam, New York, 1987.

Shainess, Natalie, *Sweet Suffering: Woman as Victim*, Bobbs-Merrill, Indianapolis, 1984.

Walker, Lenore, *The Battered Woman*, HarperCollins, New York, 1980.

On Love Dependency

Beattie, Melody, *Codependent No More*, Walker & Co., New York, 1989.

Braiker, Harriet, *The Type E Woman: How to Overcome the Stress of Being Everything to Everybody*, NAL-Dutton, New York, 1987.

Cowain, Dr. Connell and Kinder, Dr. Melvyn, *Women Men Love / Women Men Leave*, NAL-Dutton, New York, 1990.

Dowling, Colette, *The Cinderella Complex: Women's Hidden Fears of Independence*, Pocket, New York, 1990.

Forward, Susan, Ph.D. & Torres, Joan, *Men Who Hate Women and the Women Who Love Them,* Bantam, New York, 1986.

Friedman, Sonya, *Men are Just Desserts,* Warner, New York, 1983.

Freidman, Sonya, *Smart Cookies Don't Crumble,* Putnam, New York, 1985.

Leman, Kevin, *The Pleasers: Women Who Can't Say No — and the Men Who Control Them,* Dell, New York, 1992.

Norwood, Robin, *Letters From Women Who Love Too Much,* Pocket, New York, 1988.

Peele, Stanton, *Love & Addiction,* Taplinger Publishers, New York, 1975.

Shainess, Natalie, *Sweet Suffering: Woman as Victim,* BantamBooks, New York, 1982.

On Positive Thinking

DeRosis, Helen A., The Book of Hope: How Women can Overcome Depression, Bantam, New York, 1983.

Dyer, Wayne, *Pulling Your Own Strings,* Avon, New York, 1979.

Gawain, Shakti, *Creative Visualization,* New World Library, San Rafael, 1978.

Hay, Louise, *Heal Your Body,* Hay House, Santa Monica, 1988.

Marshall, John A., *Find Your Perfect High,* Grassroots Educational Service, Glendale, CA 1978.

Murphy, Joseph, *The Power of Your Subconscious Mind,* Prentice Hall, Englewood Cliffs, 1963.

Peck, M. Scott, *The Road Less Traveled,* Simon & Schuster, New York, 1978.

Ross, Ruth, *Prospering Woman: A Complete Guide to Achieving the Full Abundant Life,* New World Library, San Rafael, 1982.

Stoddard, Alexandria, *Living a Beautiful Life: 500 Ways to Add Elegance, Order, Beauty, and Joy to Every Day of Your Life,* Avon, New York, 1988.

Daily Readings

Anonymous, *A Day At A Time,* CompCare, Minneapolis, 1989.

Lerner, Rokelle, *Daily Affirmations for Adult Children,* Health Communications, Inc., Pompano Beach, 1985.

RESOURCES

Names and addresses change frequently; movement groups are created and dissolve. We will attempt to keep up-to-date with changes of the most relevant groups. If you wish to receive such an update, send a stamped, self-addressed legal-sized envelope to: Volcano Press SB, P.O. Box 270, Volcano, CA 95689-0270.

Alcoholism

- **Adult Children of Alcoholics.** A twelve-step program of recovery for adults who were raised in an alcoholic, dysfunctional family. Newsletter.
 International — Write: P.O. Box 35623, Los Angeles, CA 90035. Call (213) 464-4423

- **Al-Anon Family Group.** Support for family members and friends affected by a problem drinker.
 International — Write: P.O. Box 862, Midtown Station, New York, NY 10018. Call (212) 302-7240.

- **AlaTeen/Ala-Preteen/AlaTot.** Fellowship of children who live with an alcoholic. Helps members learn coping.
 International — Write: Al-Anon Family Group Headquarters. P.O. Box 862, Midtown Station, New York, NY 10018. Call (212) 302-7240.

- **Alcoholics Anonymous.** A fellowship of individuals who want to solve common problems and help each other recover from alcoholism. Group guidelines. Newsletter.
 International — Write: Box 475 Riverside Drive, New York, N.Y. 10163. Call (212) 686-1100

- **National Association for Children of Alcoholics.** Information and support for children of alcoholics. Referrals to meetings.
 National — Write: 31582 Coast Highway, Suite B, South Laguna, CA 92677. Call (714) 499-3889.

- **Women for Sobriety.** Supportive program designed to help women alcoholics achieve sobriety and overcome depression and guilt.
 National — Write: Box 618, Quakertown, PA 18951. Call (215) 536-8026.

Anorexia/Bulimia

- **American Anorexia & Bulimia Association, Inc.** Provides referrals, information, annual conferences, and support groups for anorexics, bulimics, and their families. Group Guidelines. Newsletter.
 National — Write: 418 E. 76 St., New York, NY 10021. Call (212) 734-1114.

- **Anorexia/Bulimia.** Provides public information on self-help groups, therapy, and referrals to professionals.
 International — Write: P.O. Box 7, Highland Park, IL 60035. Call (312) 831-3438.

- **Anorexia Nervosa and Related Eating Disorders.** Provides support groups, medical referrals, and counseling for anorexics, bulimics, and their families.
National — Write: P.O. Box 5102, Eugene, OR 97405. Call (503) 344-1144.

- **B.A.S.H. (Bulimia Anorexia Self-Help)**. Information for the anorexic or bulimic, and the family. Free literature. Newsletter. Annual conference. Group facilitator's manual.
National — Write: 6125 Clayton Ave., Suite 215, St. Louis, MO 63139.
Call (314) 991-BASH or 800-BASH-STL.

- **National Anorexic Aid Society, Inc.** Support and education for people suffering from anorexia, bulimia and related eating disorders and their families and friends. Newsletter, information, referrals, films, and videotapes. Guidelines for starting support groups.
Model — Write: 1925 E. Dublin- Granville Rd., Columbus, OH 43229.
Call (614) 436-1112.

Child Abuse

- **Parents Anonymous.** Help for parents who are physically or emotionally abusing their kids, or fear they may. Information and referrals. Group guidelines. Newsletter.
National — Write: 520 S. Lafayette, Suite 316, Los Angeles, CA 90057.
Call (800)-421-0353.

- **S.P.E.A.K.S. (Survivors of Physical and Emotional Abuse As Kids)**. Self-help groups which enable adults to talk about physical or emotional abuse in childhood.
Regional — Write: c/o Parents Anonymous, 520 S. Lafayette, Suite 316, Los Angeles, CA 90057. Call (800)-421-0353.

- **Victims of Child Abuse Laws (V.O.C.A.L.)** Seeks to protect persons accused of child abuse. Referral to psychologists and attorneys.
National — Write: P.O. Box 1314, Orangevale, CA 95662. Call (916) 863-7470.

Domestic Violence

- **Batterers Anonymous.** Self-help program for men who want to control their anger abuse toward women. Manuals.
National — Write: 16913 Lerner Ln., Fontana, CA 92335. Call Dr. Jerry Goffman, (714) 884-6809.

- **Clearinghouse On Family Violence Information**. Information services to practioners and researchers studying family violence prevention. Assists victims of family violence.
National — Write: P.O. Box 1182, Washington, D.C. 20013. Call (703) 385-7565.

- **Emerge: A Men's Counseling Service On Domestic Violence.** Technical assistance and training on counseling techniques on abuse of woman.
National — Write: 18 Hurley, Cambridge, MA 02139. Call (617) 547-9870.

- **National Coalition Against Domestic Violence.** Grassroots coalition of battered woman's service organizations and shelters.
 Write: P.O. Box 34103, Washington, D.C. 20043-4103. Call (202) 638-6388.

Employment

- **Employment Support Center.** Develops self-help support groups for the unemployed and underemployed. Network of group leaders and employment professionals. Provides how to manual and assistance to replicate program in other cities.
 Write: Suite 444, 900 Massachusetts Ave., NW, Washington, DC 20001.
 Call (202) 783-4747.

- **Women Employed.** Promotes economic equity for women. Career development services, networking, conferences. Newsletter.
 National — Write: 22 W. Monroe, Suite 1400, Chicago, IL 60603. Call (312) 782-3902.

- **Option Inc.** Career advisory and human resource consulting service. Offers counseling on career issues such as job searches, career changes, and career development.
 Write: 215 S. Broad St., 5th Floor, Philadelphia, PA 19107. Call (215) 735-2202

Gambling/Debt

- **Debtors Anonymous**. Group support to help members set budgets and develop saving habits. "Help Yourself Out Of Debt Kit." Group organizing kit.
 Model — Write: Women's Center, 198 Broadway, New York, NY 10038.
 Call (212) 964-8934.

- **Debtors Anonymous General Service Board**. A twelve-step program to help in recovery from compulsive indebtedness.
 National — Write: P.O. Box 20322, New York, NY 10025-9992. Call (212) 642-8220.

- **Gam-Anon Family Groups**. Help for family members and friends of compulsive gamblers. Gam-A-Teen groups for teens. Group development guidelines and literature available.
 National — Write: P.O. Box 157, Whitestone, NY 11357. Call (718) 352-1671.

- **Gamblers Anonymous.** Support for men and women who want to recover from compulsive gambling. Chapter development kit. Monthly bulletin for members.
 International — Write: P.O. Box 17173, Los Angeles, CA 90017. Call (213) 386-8789.

Manic-Depression/Depression

- **Depression After Delivery.** Support and information for women who have suffered from *post partum* depression. Newsletter, group development guidelines, pen pals, conferences.
 Regional — Write: P.O. Box 1282, Morrisville, PA 19067. Call (215) 295-3994.

- **Depressives Anonymous.** Helps anxious and depressed persons change troublesome behavior patterns.
 Model — Write: 329 E. 62nd St., New York, NY 10021. Call (212) 689-2600 (answering service).

- **National Depressive & Manic Depressive Association.** Support and information for manic depressives, depressives, and their families. Provides public education on the biochemical nature of manic depression.
 National — Write: 730 N. Franklin, Suite 501, Chicago, IL 60610. Call (312) 642-0049.

- **National Organization for Seasonal Affective Disorder (N.O.S.A.D.).** Disseminates information and education about causes, nature and treatment of SAD, encourages research into causes and treatment. Newsletter, information and referrals, support groups to be developed.
 National — Write: P.O. Box 451, Vienna, VA 22180.

- **Depression and Related Affective Disorders Association.** Provides support services including referrals, education, networking, and consultation. Encourages the formation of local support groups.
 Write: John Hopkins Hospital, Meyer 3-181, 600 N. Wolfe St., Baltimore, MD 21205. Call (301) 955-4647.

Marriage/Separation/Divorce

- **Association of Couples in Marriage Enrichment.** Network of couples who want to enhance their relationships. Local chapters sponsor support groups, retreats, workshops.
 Association — Write: P.O. Box 10596, Winston-Salem, NC 27108.
 Call (919) 724-1526.

- **Committee for Mother & Child Rights.** Information for mothers with custody problems. Telephone support network.
 National — Write: Rt. 1, Box 256 A, Clearbrook, VA 22624. Call (703) 722-3652.

- **Interracial Family Alliance.** Support for interracial couples, their children, biracial adults and interracial adoptive families. Sharing the concerns of raising interracial children, family rejection, and housing discrimination. Phone and mail network. Newsletter.
 Write: P.O. Box 16248, Houston, TX 77222. Call (713) 454-5018.

- **Mothers Without Custody.** Network to enhance life for women who are living apart from one or more of their children. Public education, newsletter, coordinators kit.
 National — Write: P.O. Box 27418, Houston, TX 77256. Call (713) 840-1622.

- **National Organization for Changing Men (NOCM).** Network of resources and support for men and for equality for both men and women. Newsletter.
 Write: 794 Pennsylvania Ave., Pittsburg, PA 15221. Call (412) 371-8007.

- **National Organization for Men.** Seeks equal rights for men, uniform national divorce, custody, property and visitation law. Educational seminars. Newsletter. Write: 11 Park Pl., New York, NY 10007. Call (212) 686-MALE.

- **North American Conference of Separated & Divorced Catholics**. Educational, psychological and religious aspects of divorce and remarriage are addressed through self-help groups, conferences and training programs. All faiths are welcome. Group development guidelines. Newsletter.
 National — Write: 1100 S. Goodman St., Rochester, NY 14620. Call (716) 271-1320.

- **Organization for the Enforcement of Child Support.** Education, support and advocacy for custodial parents regarding problems in collecting child support. Research and referrals, workshops, lobbying efforts.
 National — Write: 119 Nicodemus Road, Reistertown, MD 21136. Call (301) 833-2458.

- **Woman Helping Woman.** Offers mutual support and exchange of ideas for those going through the divorce process. Emphasis on woman over 40 and those married for 20 or more years.
 Model — Write: 525 N. Van Buren St., Stoughton, WI 53589. Call (608) 873-3747.

- **Worldwide Marriage Encounter.** Multi-faith group aims to renew couple relationships through presenting communication tools. National magazine. Local phone networking, neighborhood sharing groups.
 Worldwide — Write: 1908 E. Highland, San Bernardino, CA 92404. Call (714) 881-3456.

Mental Health

- **Co-Dependents Anonymous.** Local groups, fellowship of men and women whose common problem is an inability to maintain healthy relationships. 21-step program.
 National — Write: P.O. Box 33577, Phoenix, AZ, 85067-3577. Call (602) 277-7991.

- **Emotions Anonymous**. Fellowship sharing experiences of trying to have better emotional health, hopes and strengths with each other. Newsletter, pen pals, development guidelines.
 National — Write: P.O. Box 4245, St. Paul, MN 55104. Call (612) 647-9712.

- **Emotional Health Anonymous.** Fellowship of people who share experiences so that they may solve common problems of mental health. Newsletter, development guidelines.
 National — Write: P.O. Box 63236, Los Angeles, CA 90063-0236. Call (213) 268-7220.

- **International Association for Clear Thinking.** For people interested in having a more effective and satisfactory lifestyle. Principles of clear thinking and self-counseling. Group facilitator training program.
 30 Chapters — Write: P.O. Box 1011, Appleton, WI 54912. Call (414) 739-8311.

- **National Alliance of Psychiatric Survivors.** Self-help groups to improve the quality of life for current & former recipients of mental health services.
 National — Write: P.O. Box 618, Sioux Falls, SD 57101. Call (605) 334-4067.

- **Obsessive-Compulsive Foundation.** Dedicated to preventing, controlling and finding a cure for O.C.D., and improving the welfare of people with O.C.D. Research, education, mutual support.
 National — Write: P.O. Box 9573, New Haven, CT 06535. Call (203) 772-0565.

- **Obsessive-Compulsive Anonymous.** Twelve-step self-help group for people with obsessive-compulsive disorder. Assistance starting groups.
 Model — Write: P.O. Box 215, New Hyde Park, NY 11040. Call (516) 741-4901.

- **Recovery.** Mental health organization offering self-help method for controlling temperament and behavior and changing attitudes toward nervous symptoms and fears.
 National — Write: 802 N. Dearborn S., Chicago, IL 60610. Call (312) 337-5661.

- **S.A.F.E. (Self Abuse Finally Ends).** Network to help individuals desiring information and support for self injurious behavior. Assistance available for starting groups.
 National — Write: P.O. Box 267810, Chicago, IL 60626. Call (312) 722-3113.

- **Youth Emotions Anonymous.** Using the twelve-step program, youth ages 13-19 are encouraged to develop healthy emotions, habits, and attitudes.
 National — Write: P.O. Box 4245, St. Paul, MN 55104. Call (612) 647-9712.

Overweight

- **O-Anon.** Fellowship of friends & relatives of compulsive overeaters. Twelve-step program.
 International — Write: P.O. Box 4305, San Pedro, CA 90731. Call (213) 547-1570.

- **Overeaters Anonymous.** Fellowship of individuals meeting to help one another understand and overcome compulsive overeating. Twelve-step program. Groups and literature for teens.
 National — Write: P.O. Box 92870, Los Angeles, CA 90009. Call (213) 320-7941.

- **National Association to Advance Fat Acceptance (NAAFA).** Aid to members who want to develop self-esteem and self-confidence in themselves as they are. Education regarding obesity.
 National — Write: P.O. Box 188620, Sacramento, CA 95818. Call (516) 352-3120.

- **T.O.P.S. (Take Off Pounds Sensibly).** Aids overweight people attain and maintain their goal weights. Promotes a sensible approach to weight control. Weekly meeting for discussion.
 National — Write: P.O. Box 07360, 4575 South Fifth St., Milwaukee, WI 53207. Call (414) 482-4620.

Parenting

- **Child Find of America, Inc.** Assistance for parents of missing children. Mediation in cases of parental abduction, child safety and public awareness programs. Photo directory.
 National — Write: P.O. Box 277 New Paltz, NY 12561. Call 1-800-I-AM-LOST or 1-800-A-WAY-OUT, or (914) 255-1848.

- **Mothers At Home.** Support for mothers who want to stay home and raise their children.
 National — Write: P.O. Box 2208, Merrifield, VA 22116. Call (703) 352-2292.

- **National Association of Mothers' Center.** Advocacy, support system for those involved in parenting, pregnancy, childbirth and child rearing. Free networking and consultation.
 National — Write: 129 Jackson St., Hempstead, NY 11550. Call 1-800-645-3838, in NY State call (516) 486-6614.

- **Parents Helping Parents.** Support and education for families of disabled children. Parent groups. Support and activities for siblings.
 Model — Write: 535 Race St., Suite 140, San Jose, CA 95126. Call (408) 288-5010.

- **Parents Without Partners.** Educational organization of single parents.
 National — Write: 8807 Colesville Road., Silver Spring MD 20910. Call (301) 588-9354.

- **Pilot Parents Program.** Support and resources for parents of newly diagnosed handicapped children. Assistance in starting program.
 Model — Write: 3610 Dodge St., Omaha, NE 68131. Call (402) 346-5220.

- **Post Partum Support, International.** Emotional support to parents, telephone help and discussion groups. Education on basic infant care and parent adjustment. Guide for establishing a program.
 Model — Write: 927 N. Kellogg Ave., Santa Barbara, CA 93111. Call (805) 967-7636.

- **Single Mothers by Choice.** Support network for women having children while not in a permanent relationship.
 National — Write: P.O. Box 1642, Gracie Square Station, New York, NY 10028. Call (212) 988-0993.

- **Single Parent Resource Center.** Single parent self-help groups, referral, information, and consultation.
 International — Write: 141 W. 28th St., Suite 302, New York, NY 10001. Call (212) 947-0221.

- **Single Parents Society.** Supports the interests of previously married single parents.
 Model — Write: 527 Cinnaminson Ave., Palmyra, NJ 08065. Call (609) 424-8872.

- **Stepfamily Association of America.** Advocacy and information for stepfamilies. Self-help programs through local chapters.
 National — Write: 215 Centennial Mall S., Suite 212, Lincoln, NE 68508.
 Call (402) 477-7837.

- **Tough Love.** Self-help program for parents, kids and communities for dealing with the out-of-control behavior of a family member.
 International — Write: Tough Love, Box 1069, Doylestown, PA 18901.
 Call (215) 348-7090

- **Women On Their Own, Inc. (W.O.T.O.).** For women raising children on their own. Provides support, networking, advocacy, speakers bureau to increase public awareness and special loans.
 National — Write: P.O. Box 1026, Willingboro, NJ 08328. Call (609) 728-4071.

Substance Abuse

- **Cocaine Anonymous.** Fellowship of men and women who want to solve their common problems, to recover from addiction. Group starter kit available.
 International — Write: 3740 Overland Ave., Suite G., Los Angeles, CA 90034.
 Call (213) 599-5833.

- **Drug-Anon Focus.** Support for friends and relatives of people who are dependent on mood-altering chemicals. Newsletter, chapter development guidelines.
 Model — Write: Park West Station, P.O. Box 20806, New York, NY 10025.
 Call (212) 484-9095.

- **Drugs Anonymous (Formerly Pills Anonymous).** Supportive twelve-step program for those who want to help themselves and others recover from chemical addiction.
 National — Write: P.O. Box 473, Ansonia Station, New York, NY 10023.
 Call (312) 874-0700

- **Families Anonymous.** Fellowship of relatives and friends of people involved in the abuse of mind-altering substances. Based upon the twelve-step program adapted from A.A.
 National — Write: P.O. Box 528 Van Nuys, CA 91408. Call (818) 989-7841.

- **Nar-Anon Family Groups, Inc.** Fellowship network of friends and relatives concerned about drug abuse. Twelve-step program. Provides group packet for starting new groups.
 International — Write: Nar-Anon Family Group Headquarters, P.O. Box 2562, Palos Verdes, CA 90274-0119. Call (213) 547 5800.

- **Narcotics Anonymous.** Fellowship of men and women who have problems with drugs. Recovering addicts meet regularly. Magazine, Pen pal program, phone network, group development guidelines. Braille in seven languages, audio-tapes, literature.
 International — Write: P.O. 9999, Van Nuys, CA 91409. Call (818) 780-3951.

Sexual Abuse / Incest / Rape

- **Believe the Children.** Support for parents of children who have been victimized by people outside of the family. Addresses the issues of sexual and ritualistic exploitation of small children.
 National — Write: P.O. Box 77, Hermosa Beach, CA 90254. Call (213) 379-3514.

- **Incest Survivors Anonymous.** Members meet to share their experience, hope and strength, so that they may recover from their incest experience. Assistance in starting groups.
 International — Write: P.O. Box 5613, Long Beach, CA 90805-0613. Call (213) 428-5599.

- **Incest Survivors Resource Network,** International. Resource for professionals on all aspects of incest. Monthly group meetings for incest survivors. Group development guidelines.
 International — Write: P.O. Box 7375, Las Cruces, NM 88006-7375. Call (505) 521-4260.

- **Molesters Anonymous.** Self-help groups to provide support for men who molest children. Groups are initiated by a professional. Group development manual.
 Model — Write: c/o Batterers Anonymous, 16913 Lerner Ln., Fontana, CA 92335. Call Dr. Jerry Goffman (714) 884-6809.

- **Parents Against Molesters, Inc.** Support for parents of children who were victims of sexual abuse. Awareness program to community. Advocacy for legislation. Phone support network, Group development guidelines.
 Model — Write: P.O. Box 3557, Portsmouth, VA 23701. Call Barbara Barker (804) 363-2549.

- **Parents United.** Support groups for parents whose children have been sexually abused, as well as for adults who were molested in childhood. Training and chapter development guidelines available for professionals.
 National — Write: 232 E. Gish Rd., San Jose, CA 95108. Call (408) 453-7616.

- **S.A.R.A. (Sexual Assault Recovery Anonymous) Society**. Self-help and education for adults and teens who were sexually abused as children. Assistance for starting groups, group development guidelines, and literature available.
 National — Write: P.O. Box 16, Surrey, B.C. Canada V3T 4W4.

- **Survivors of Incest Anonymous.** Self-help program for men and women who have been victims of child sexual abuse.
 International — Write: P.O. Box 21817, Baltimore, MD 21222-6817. Call (301) 433-2365.

- **V.O.I.C.E.S. In Action (Victims of Incest Can Emerge Survivors).** Network for adult victims of childhood sexual abuse.
 National — Write: P.O. Box 148309, Chicago, IL 60614. Call (312) 327-1500.

Sexuality

- **Augustine Fellowship, Sex & Love Addicts Anonymous.** Support for obsessive/compulsive sexual behavior. Group development guidelines, literature, and Newsletter. **International** — Write: P.O. Box 119, New Town Branch, Boston, MA 02258. Call (617) 332-1845.

- **CO-S.A. (Codependents of Sex Addicts).** Self-help program for those involved in relationships with people who have compulsive sexual behavior. **Write**: Twin Cities CO-S.A., P.O. Box 14537, Minneapolis, MN 55414. Call (612) 537-6904.

- **Dignity.** Organization of lesbian and gay Catholics and their friends. Concerned with spiritual development, advocacy, and education. **National** — Write: Dignity, Suite 11, 1500 Massachusetts Ave., NW. Washington, DC 20005. Call (202) 861-0017.

- **Federation of Parents & Friends of Lesbians & Gays (Parents F.L.A.G.).** Support for families who want to understand their gay family member; committed to educating the community. Parent support groups. Bimonthly newsletter. Chapter development guidelines. **National** — Write P.O. Box 27605, Washington, DC 20038. Call (202) 638-4200.

- **National Gay and Lesbian Task Force.** Lobbying and advocacy for the rights of gay men and lesbians. Assistance for local gay groups. Information and referral to gay and lesbian organizations nationwide. **National** — Write: 1734 14th Street NW, Washington, DC 20009-4309. Call (202) 332-6483. Crisis line 800-221-7044.

- **Presbyterians for Lesbian/Gay Concerns.** Support for gays and lesbians in the Presbyterian church. **National** — Write: Elder James D. Anderson, P.O. Box 38, New Brunswick, NJ 08903. Call James Anderson (201) 932-7501 (day) or (201) 846-1510 (evening).

- **Sex Addicts Anonymous.** Support for men and women to share their experience to solve their common problem from compulsive sexual behavior. Educational booklet and guidelines available for starting new groups. **National** — Write P.O. Box 3038, Minneapolis, MN 55403. Call (612) 339-0217.

- **Sexaholics Anonymous.** Recovery program for those who want to stop sexually self-destructive behavior and thinking. Support to achieve and maintain sexual sobriety. **International** — Write: P.O. Box 300, Simi Valley, CA 93062. Call (805) 581-3343.

Women

- **Love-N-Addiction.** Support network to aid in recovery from love addiction. Uses the ideas from *Women Who Love Too Much* by Robin Norwood.
 National — Write: P.O. Box 759, Willimantic, CT 06226. Call (203) 423-2344.

- **National Federation of Business and Professional Women.** Organization of working women. Networking opportunities and lobbying efforts. Annual national convention, resource center, periodic publications, and bimonthly magazine.
 National — Write: 2012 Massachusetts Ave., NW. Washington, DC 20036.
 Call (202) 293-1100.

- **National Organization For Women.** Women and men committed to equal rights. Education meetings, advocacy. Chapter development guidelines, and newsletter.
 National — Write: 1000 16th St. N.W., Washington, DC 20005. Call (202) 331-0066.

- **National Women's Health Network.** Education on women's health issues through the clearinghouse. Information and referral.
 National — Write: 1325 G Street, NW, Lower Level, Washington, DC 20005.
 Call (202) 347-1140.

- **Women Employed.** Promotes economic equity for women through advocacy and education. Networking, career development services, conferences, newsletter.
 Write: 22 W. Monroe, Suite 1400, Chicago, IL 60603. Call (312) 782-3902.

TOLL-FREE NATIONAL HELPLINES

• AIDS	800-342-2437 800-822-7422 800-234-8336	(M-F 5-10, Sat 1-5) National Information line (M-F 10-2) Project Inform AIDS teen information line
• Alcohol	800-ALCOHOL 800-732-9808	(24 hours) Doctor's Hospital of Worcester South Oaks Hospital Alcoholism and Compulsive Gambling Programs
• Alcoholics Anonymous		Check the white pages of your local telephone book
• Anorexia/ Bulimia	800-BASH-STL	Bulimia Anorexia Self-Help
• Attorney	800-624-8846	Attorney Referral Network
• Cocaine	800-662-HELP	National Institute on Drug Abuse
• Drug Abuse	800-662-HELP	(M-F 9 am - 3 am, Sat - Sun 12-3 am) National Institute on Drug Abuse—Referrals
• Endometriosis	800-992-ENDO	(24 hours) Endometriosis Association
• Head Injury	800-444-NHIF	National Head Injury Foundation
• Lupus	800-558-0121	(M-F 10-5:30) Lupus Foundation
• Missing Children	800-843-5678 800-I-AM-LOST 800-235-3535	(M-F 7 am - Midnight, Sat 10-6) National Center for Missing and Exploited Children ChildFind (24 hours) The Missing Children Network
• Narcotics Anonymous		Check telephone book for local listing or write Narcotics Anonymous, World Service Office, P.O. Box 9999, Van Nuys, CA 91409
• Overeaters		Check telephone book for local listing
• Parents	800-421-0353	Parents Anonymous —for those losing their temper with their kids

Toll-Free National Helplines (continued)

• PMS	800-222-4-PMS	Madison Pharmacies — premenstrual syndrome
• Runaways	800-621-4000	(24 hours) National Runaways
• Smokenders	800-323-1126	
• Sexaholics		Check telephone book for local listing

Volcano Press publishes titles of special interest to women:

_____ **Menopause, Naturally: Preparing for the Second Half of Life,** Updated, by Sadja Greenwood, M.D., M.P.H. $13.95

_____ **Menopausia sin ansiedad: como prepararse para la segunda mitad de la vida.** Spanish edition of Menopause, Naturally. $13.95

_____ **Goddesses** by Mayumi Oda. Drawing her full-color images from old Japanese prints, Oda transforms traditional Buddhist gods into their joyous female counterparts. Accompanied by a lyrical, political autobiography. $14.95

_____ **Period.** by JoAnn Gardner-Loulan, Bonnie Lopez, and Marcia Quackenbush. A friendly, supportive book on menstruation, written and illustrated in a reassuring, informative way for girls and their parents. With a removable Parents' Guide. $9.95

_____ **La Menstruación: Qué es y cómo prepararse para ella.** Spanish edition of Period. $9.95

_____ **El lenguaje de la sexualidad para la mujer y la pareja.** by Yael Fischman, Ph.D. Informed, comprehensive answers to frequently asked questions about sexuality by a Latina therapist. In Spanish. $11.00

_____ **Conspiracy of Silence: The Trauma of Incest** by Sandra Butler. Thoroughly researched and well documented, while encouraging the individual to understand and resolve personal issues. $12.95

_____ **Battered Wives** by Del Martin. The first and still the best introduction to the problem of abuse. $11.95

_____ **Learning to Live Without Violence: A Handbook for Men**, Updated, by Daniel J. Sonkin, Ph.D. and Michael Durphy, M.D. A 14-week program providing batterers with techniques for redirecting their anger and developing healthier relationships. $11.95

_____ **Learning to Live Without Violence: A Worktape for Men.** 2 C-60 cassettes, adapted from the book. A valuable tool to use by itself, or in conjunction with the book. $15.95

_____ **Sourcebook For Working With Battered Women** by Nancy Kilgore. A manual for counselors, therapists, and other professionals working with abused women. $17.95

_____ **Every Eighteen Seconds** by Nancy Kilgore. Probes a violent male-female relationship in the form of letters from an abused woman. Includes a self-help education section, and national resources. $8.95

_____ **Lesbian/Woman** by Del Martin and Phyllis Lyon. The 20th Anniversary Edition of a ground-breaking classic updated to include events of the past twenty years. Describes lesbian lives and experiences in a positive, knowledgeable way. $25.00

_____ **Women for Positive Relationships: A Comprehensive Manual on Love Dependency** by Nancy Kilgore. A manual specifically designed for working with love-dependent women in group or individual settings. $19.95

These books can be purchased or ordered from your local bookstore, or directly from Volcano Press at P.O. Box 270, Volcano, CA 95689 (209) 296-3445, Fax (209) 296-4515.

To order, send this form, your order, and a check or money order for the price of the book(s) plus $4.50 shipping & handling for the first book, and $1.00 for each additional book ordered to:

Volcano Press
P.O. Box 270 SB
Volcano, CA 95689

Phone (209) 296-3445
Fax (209) 296-4515

California residents please add appropriate sales tax.

Name _____

Address _____

City _____ State _____ Zip _____

☐ Please send me your free catalog.

Volcano Press books are available at quantity discounts for bulk purchases, professional counseling, educational, fund-raising or premium use. Please call or write for details.